GIFT TO

THE NATION

FRIENDS OF ART AND

PRESERVATION IN EMBASSIES

WASHINGTON, D.C.

This publication was made possible by generous grants from
The Honorable and Mrs. Ronald S. Lauder
The David and Lucile Packard Foundation.

Contents

THE WHITE HOUSE

WASHINGTON

February 27, 2001

Through its millennium project, GIFT TO THE NATION, the Friends of Art and Preservation in Embassies offer a treasure chest to the world by providing opportunities around the globe to view at our embassies the outstanding work of so many American artists. The world gains a deeper understanding of our democracy through the compelling expression of these gifted creators, emissaries, and dreamers. The paintings, sculpture, drawings, photographs, and other artworks that form this collection illustrate American society's vital and diverse nature, illuminating our country, our way of life, our culture, and the important work of American artists.

I applaud the efforts of the Friends of Art and Preservation in Embassies and extend my appreciation to the many artists and collectors who have contributed to this project. Culture is a cornerstone of our international relations, and we must always search for ways to showcase the United States' rich cultural expressions. This is an exemplary project to honor our artists and illuminate the richness of our nation's creative life.

Laura joins me in sending best wishes to participants in and viewers of the GIFT TO THE NATION project.

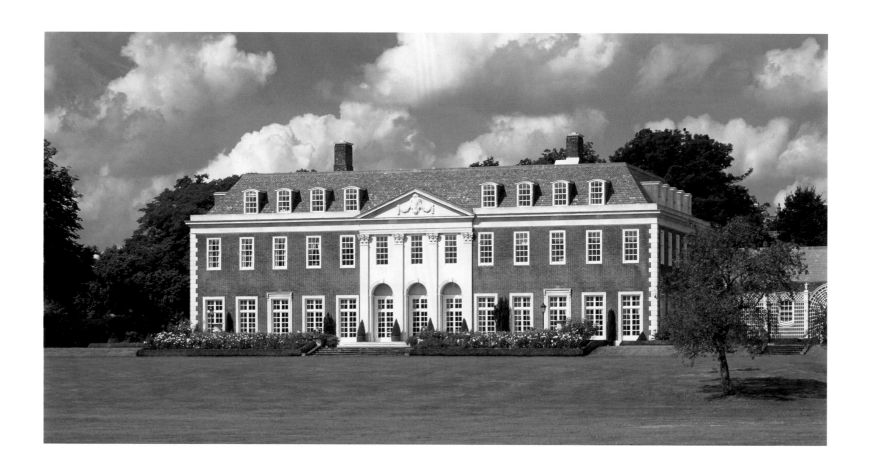

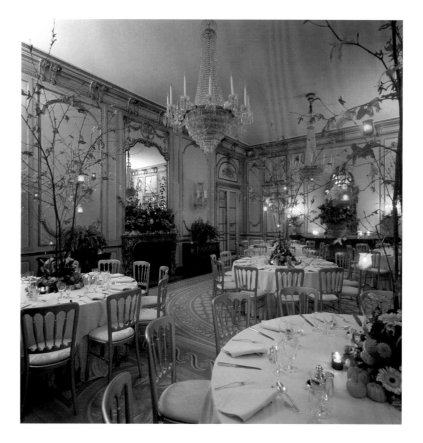

Winfield House (above), residence of the Ambassador of the United States of America to the Court of St. James's, London; preservation of representational rooms funded by The Honorable and Mrs. Walter H. Annenberg, through The Annenberg Foundation

State Dining Room, Winfield House (shown unrestored, left); restoration planned for 2001, funded by The Honorable and Mrs. Walter H. Annenberg, through The Annenberg Foundation; and The Honorable and Mrs. Charles H. Price

January 19, 2001

The Friends of Art and Preservation in Embassies (FAPE) millennium collection, GIFT TO THE NATION, will enhance our efforts to showcase great American art in our embassies and residences around the world. This gift constitutes a significant, lasting legacy of American art that will be enjoyed by future generations around the globe. It is a bold statement about the centrality of art and culture in the life of our nation and a most appropriate contribution for FAPE to make in this millennium year.

 When we created the White House Millennium Council, and thought of ways to mark this time in history that would be lasting and meaningful, we embarked on a program to "Save America's Treasures" to ensure that America's historic jewels, whether art, artifacts, or buildings, are preserved for future generations. FAPE's GIFT TO THE NATION similarly represents a lasting gift of America's creativity. We are proud that FAPE was one of our first official partners of our Millennium program.

 We salute you for the important work you do, and we will always cherish the privilege we have had to see great American art in our embassies and residences around the world, thanks to FAPE. On behalf of a grateful nation, we thank you for your millennial GIFT TO THE NATION.

Bill Clinton
Hillary

MADELEINE K. ALBRIGHT

March 13, 2001

I am writing to congratulate and thank the Friends of Art and Preservation in Embassies (FAPE) upon completion of its millennium project, GIFT TO THE NATION.

You have made a priceless contribution to American diplomacy and to overseas understanding of our country's incomparably rich and diverse culture. This is important because it is popular in some societies to deride American culture and art. It is true that America is not as old as some nations. We have no da Vinci or Rembrandt. But as the GIFT reflects, we have produced an astonishing variety of wonderful paintings, sculpture, drawings, and other art. No country has done a more remarkable job of melding the traditions of the world into a single tradition. That tradition is marked not by a unique artistic style, but rather by a common mode of artistic expression. All of the works in the GIFT were created in freedom.

As a former Secretary of State, I salute FAPE for helping to deepen the world's understanding of America's diversity and excellence. As a citizen, I thank you for the ongoing service you are providing to our country.

Madeleine Albright

January, 2001

I first became acquainted with the Friends of Art and Preservation in Embassies (FAPE) a number of years ago through my wife, Alma, who served on its board of directors. Our active involvement in the arts was encouraged by our good friends, FAPE Chairman Jo Carole Lauder and her husband, Ronald, former United States Ambassador to Vienna, who enthusiastically shared with us their love and knowledge of art.

My own appreciation of art's vital role in foreign affairs first came when I was a young Army officer serving in Germany. Since that time, I have lived with my family all over the world. We have seen firsthand the great power of art to bridge barriers of culture, language, nationality, race, and belief.

This catalogue will document FAPE's accomplishment and reinforce the important role that art and culture can play in American diplomacy.

As I travel to the Department's "front lines"—its embassies and missions abroad—I look forward to experiencing the GIFT TO THE NATION art myself. I am certain that it will inspire our employees and host-country visitors as well. I know that our ambassadors will enjoy having this very special limited-edition book for their libraries.

Alma joins me in commending FAPE for its unflagging devotion to promoting the democratic values, freedom of expression, and creativity exemplified by American art and artists. The Department and I are grateful for its service in this most worthy GIFT TO THE NATION project.

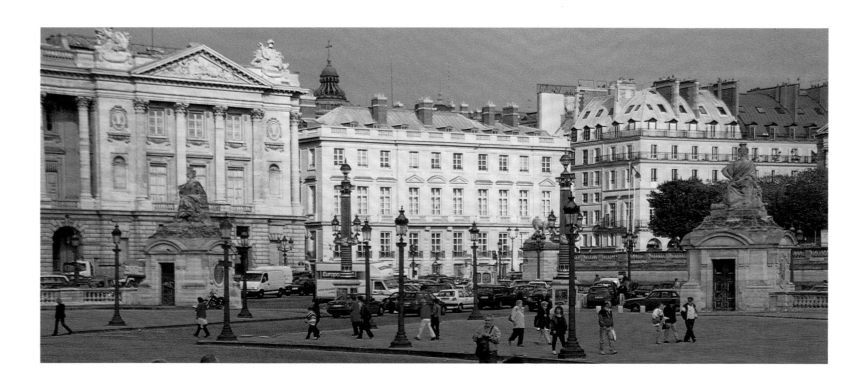

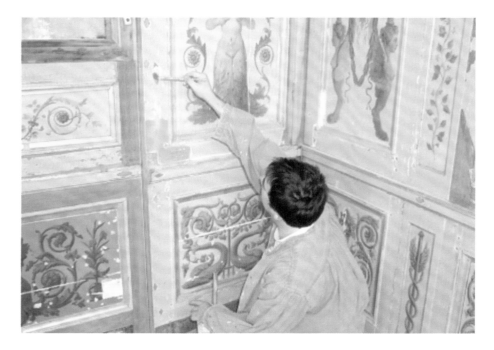

Hôtel de Talleyrand, Paris (above, center); restoration of panels and decorative elements in the Marshall Center reception rooms funded by Betty Scripps Harvey, through The Edward W. and Betty Knight Scripps Foundation

Preparing the restored panels for painting (left)

Foreword

The idea for the GIFT TO THE NATION emerged in 1997, when the Friends of Art and Preservation in Embassies (FAPE) was just beginning its second decade. Inspired by its early success, we were looking for ways to strengthen and enrich our mission. Anticipation of the millennium coincided with this pursuit, sparking our imagination. FAPE joined the White House Millennium program as one of its first partners.

FAPE has always been committed to the belief that a better understanding of our country abroad can be achieved through art. We envisioned a project that would help preserve our cultural legacy and celebrate the role of American creativity in all our accomplishments. In May of 1998, during FAPE's Annual Events in a pavilion on the South Lawn of the White House, the GIFT TO THE NATION was announced, with President and Mrs. Clinton as honorary patrons. Our first wonderful contribution was Roy Lichtenstein's *Reflections on Señorita* (1990), donated by his widow, Dorothy.

Our goal was straightforward: to assemble up to two hundred of the finest works by American artists to be donated to the State Department and installed permanently in United States embassies around the world. In addition, we undertook a major preservation project, the restoration of the panels and decorative elements of the Marshall Center reception rooms of the eighteenth-century Hôtel de Talleyrand in Paris (opposite). This magnificent historic building, once used as the headquarters for the Marshall Plan, now houses the consular offices of the American Embassy as well as the George C. Marshall Center. In addition, the GIFT TO THE NATION marks the beginning of a new phase in our long-standing relationship with Winfield House, the residence of the United States ambassador to London. We are delighted to be able to expand our commitment to this splendid neo-Georgian estate by preserving its unique representational rooms on an ongoing basis.

Assembling a collection on a national scale required a national effort. The Honorable Robin Chandler Duke, as first Millennium Committee Co-Chairman, was instrumental in gathering significant support and gifts before she was appointed Ambassador to Norway. Her able Co-Chairman, the Honorable John C. Whitehead, carried on the work of compiling the GIFT with new Co-Chairman, Douglas S. Cramer. We benefited greatly from the participation of all our donors and advisors, including almost fifty United States Senators, whose recommendations led to several regional meetings. With the generosity of so many,

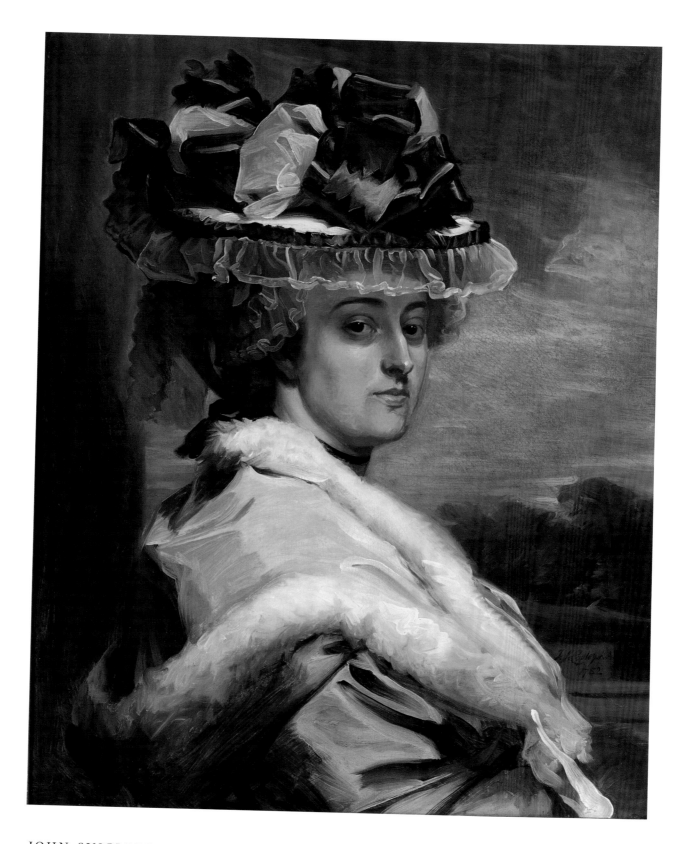

JOHN SINGLETON COPLEY

(Boston, 1738–1815)

Letitia F. Balfour, Daughter of Francis Leigh, 1782

Oil on canvas, 30 x 25 (76.2 x 63.5)

Donated by the Alex and Marie Manoogian Foundation, through
Richard Manoogian, President

PROVENANCE

David Chrichton; Max Safran; Walter P. Chrysler, Jr.; Chrysler Museum of Art,
Norfolk, Virginia; Knoedler-Modarco S.A., New York; Sotheby's, New York

Our Legacy

A remarkable historical document introduces the GIFT: the portrait of Letitia F. Balfour, painted in England in 1782 by the American Colonies' most important artist, John Singleton Copley. His political beliefs drove him to England during the Revolution, when America was a still a growing nation, spreading across the continent. The relentless progress of industrial power in the young country was accompanied by the glorification of its magnificent landscape by inspired painters. Meanwhile, objects of necessity continued to be beautifully made by hand by Native Americans, master cabinetmakers, and plain country folk.

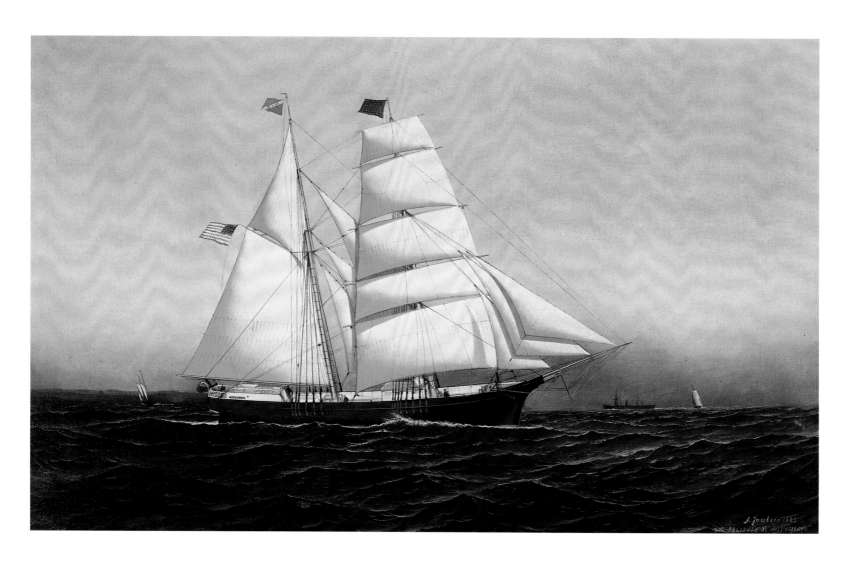

ANTONIO JACOBSEN

(Copenhagen, 1850–1921)
The American Ship Kossack Under Full Sail, 1883
Oil on canvas, 22 x 36 (55.9 x 91.4)
Donated by Carolyn and Peter Lynch

PROVENANCE
Private collection, Connecticut

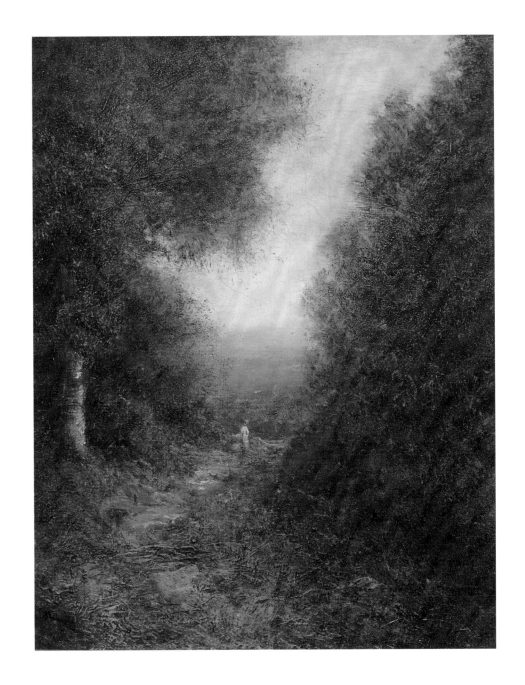

RALPH A. BLAKELOCK

(New York, 1847–1919)
Figure in a Landscape (A Woodland Path), c. 1880
Oil on canvas, 12 x 10 (30.5 x 25.4)
Donated by Shari and Michael Markbreiter

PROVENANCE
Collection of the artist; Mrs. Sellard Bullard; Private collection, New York

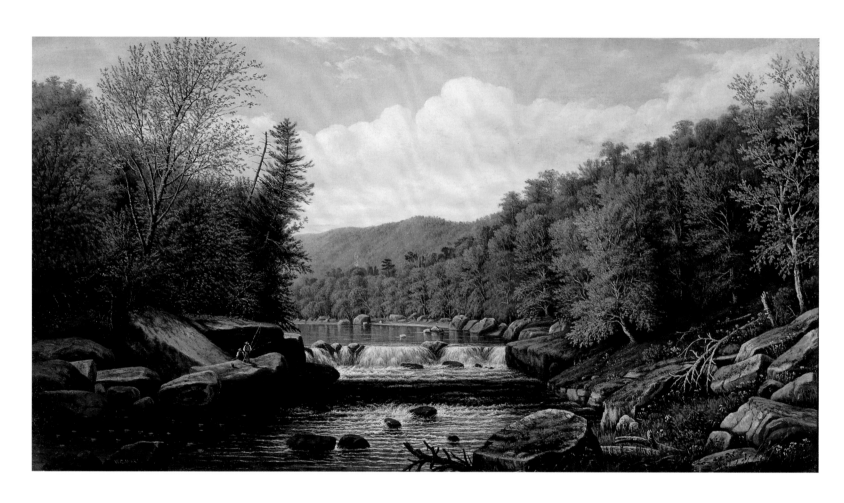

WILLIAM COVENTRY WALL

(n.p., England, 1810–1886)
The Falls in Autumn, Pennsylvania, n.d.
Oil on canvas, 20 x 36 (50.8 x 91.4)
Donated by Carolyn and Peter Lynch

PROVENANCE
The Thomas Mellon Evans Collection

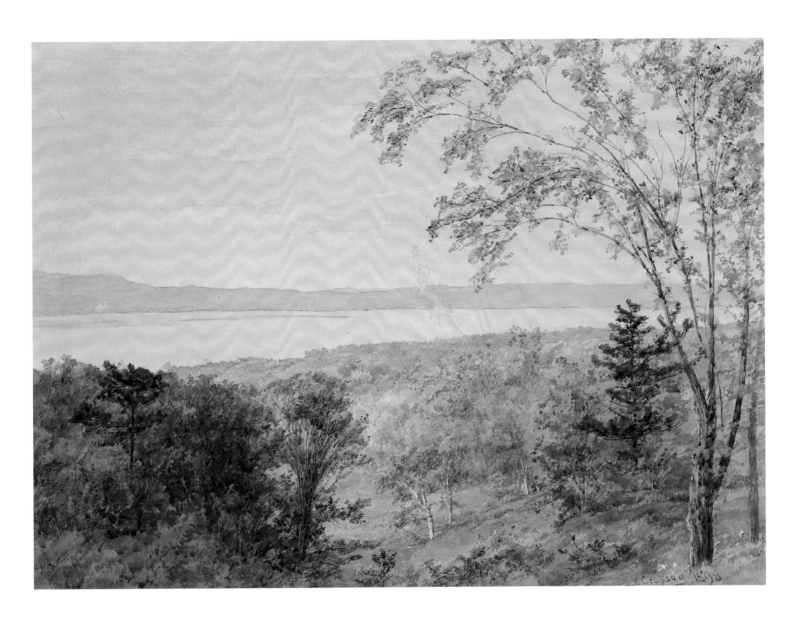

JASPER FRANCIS CROPSEY

(Staten Island, New York, 1823–1900)
View of the Hudson River with Piermont Pier, Autumn (View of the
Hudson from Longue View), 1898
Watercolor, 22¾ x 28¾ (57.8 x 73)
Donated by Mrs. John C. Newington

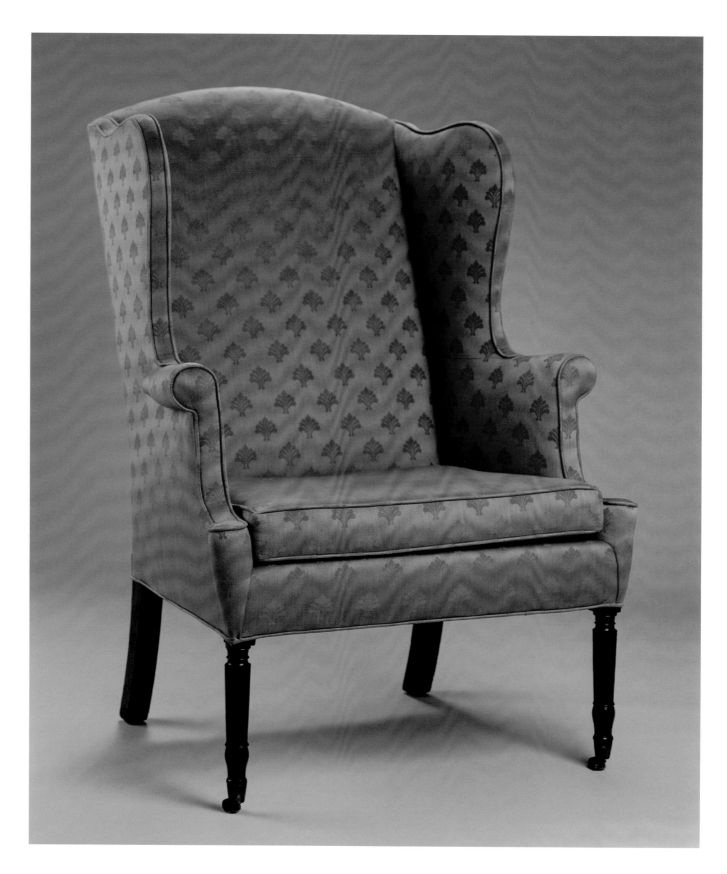

Anonymous

Wing armchair, New York, c. 1800–10
Mahogany, maple, pine, and tulipwood, 44½ x 30 x 22
(113 x 76.2 x 55.9)
Donated by Linda and George Kaufman

PROVENANCE
Henry Francis du Pont Winterthur Museum, Wilmington, Delaware

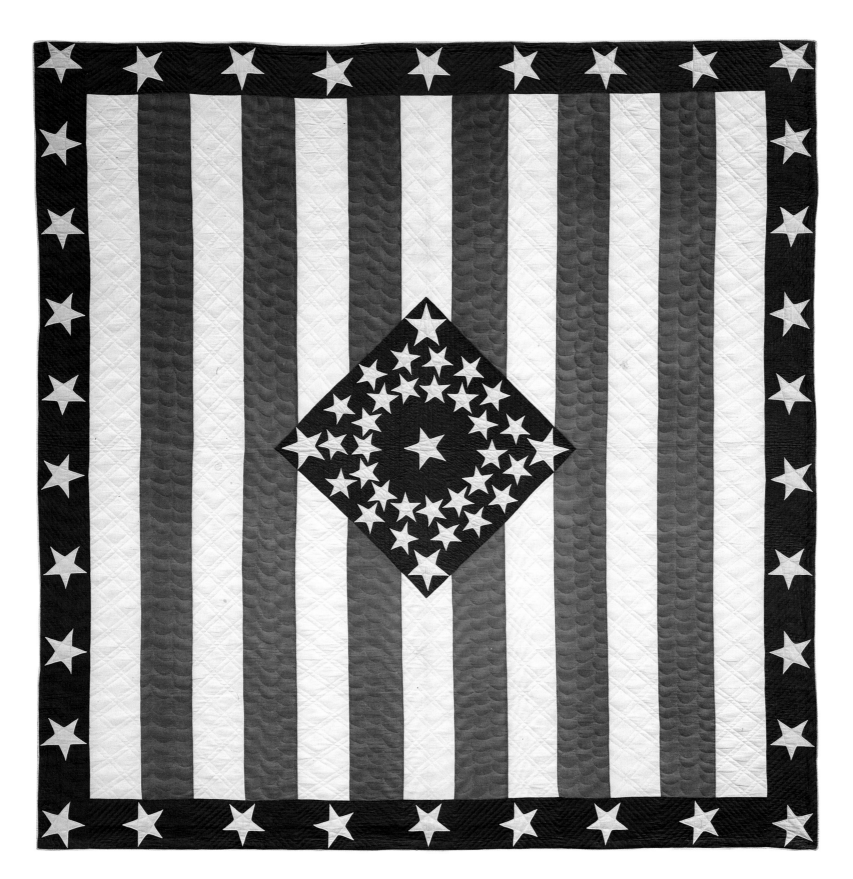

Anonymous

Stars and Bars quilt, c. 1865
Cotton and glazed chintz, 86 x 88 (218.4 x 223.5)
Donated by Ricki and Robert Conway

PROVENANCE

Hirschl & Adler Galleries, Inc., New York; America Hurrah, New York

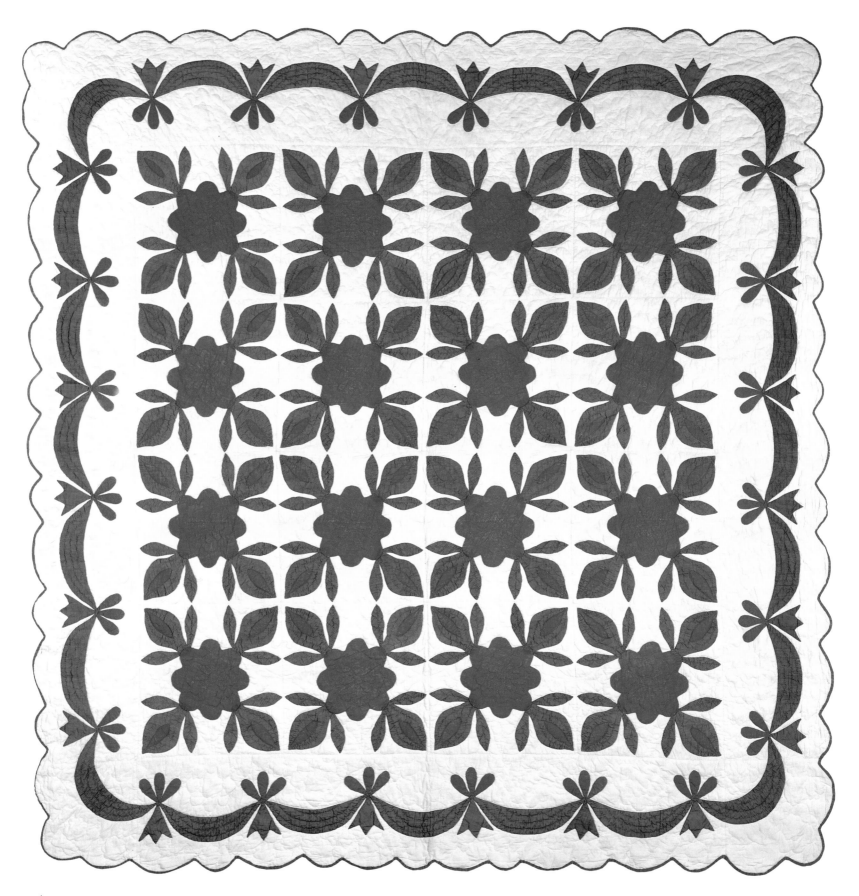

Anonymous

Rose appliqué quilt with swag border, c. 1865
Cotton, 80 x 80 (203.2 x 203.2)
Donated by Woodard & Greenstein American Antiques, New York

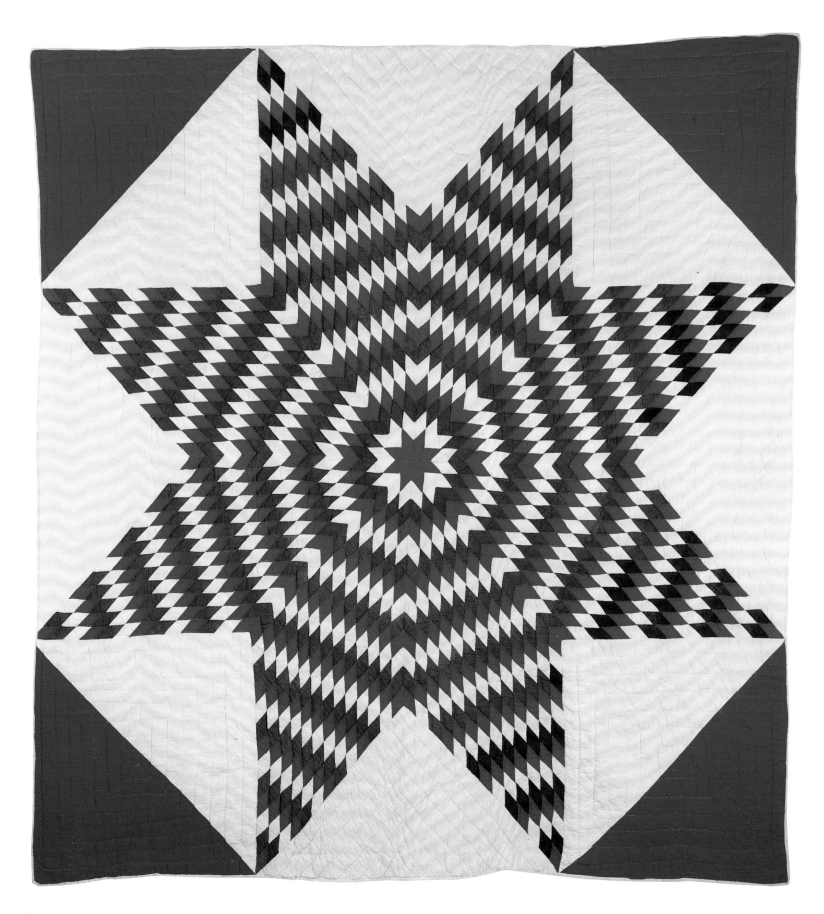

Anonymous

Lone Star quilt, c. 1890
Cotton, 80 x 75 (203.2 x 190.5)
Donated by Victoria's Antique Quilts, Victoria Hoffman, Brooklyn,
New York

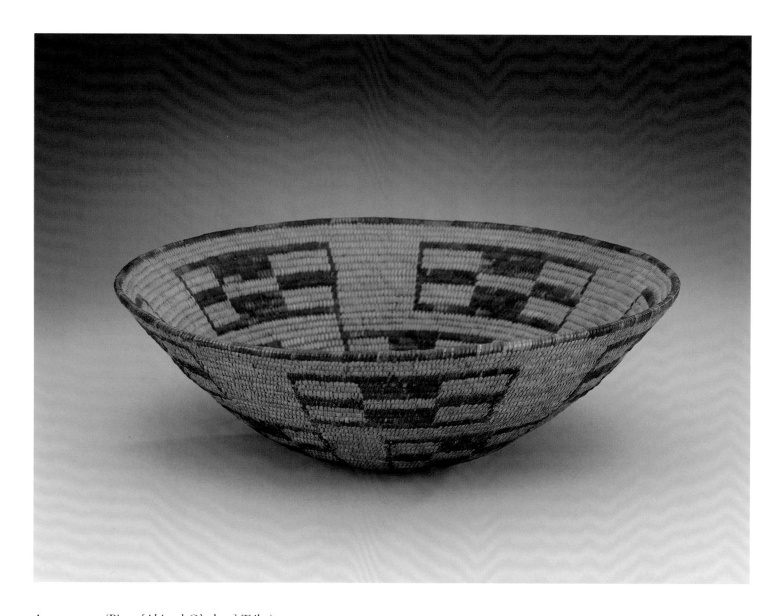

Anonymous (Pima [Akimal O'odam] Tribe)

Three basketry bowls
Donated by Joann and Gifford Phillips

Coyote tracks and turtle shell pattern, c. 1890
Cattail leaf, willow, and devil's claw, 4¼ x 14 diameter (10.8 x 35.6)

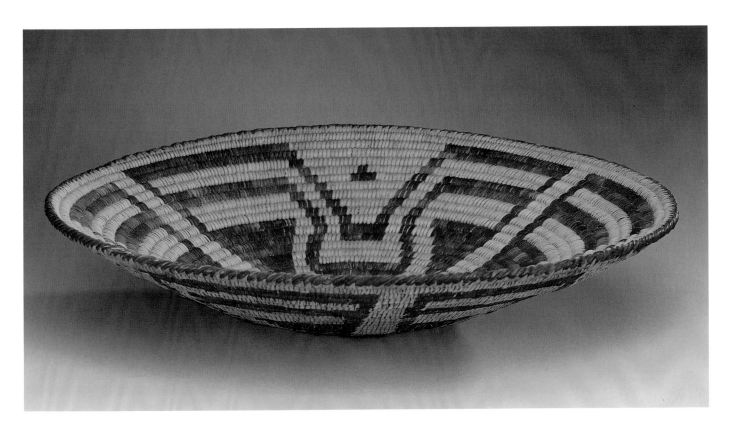

Butterfly wings pattern, c. 1890
Cattail leaf, willow, and devil's claw, 3¼ x 17 diameter (8.3 x 43.2)

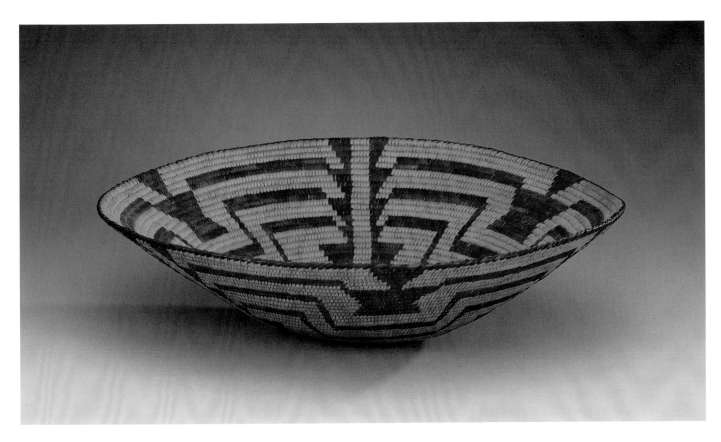

Ladder (swing) pattern, c. 1920
Cattail leaf, willow, and devil's claw, 3¼ x 14½ diameter (8.3 x 36.8)

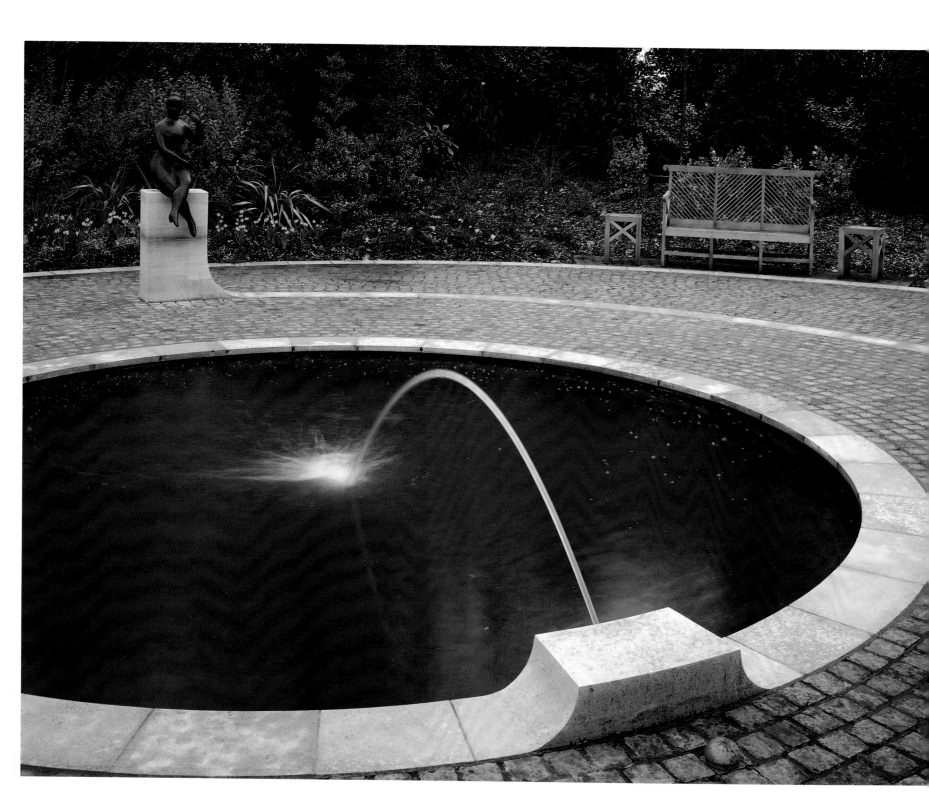

ELIE NADELMAN

(Warsaw, 1882–1946)
Seated Woman with Raised Arm, c. 1924; cast 1964
Bronze, 46 x 19 x 25 (116.8 x 48.3 x 63.5)
Edition of six
Purchased with funds donated by Janice H. Levin
Installed in the Janice H. Levin Sculpture Garden, designed by
Morgan Wheelock, at Winfield House, United States Ambassador's
Residence, London; funded by Janice H. Levin

PROVENANCE
Estate of the artist; Salander-O'Reilly Galleries, New York

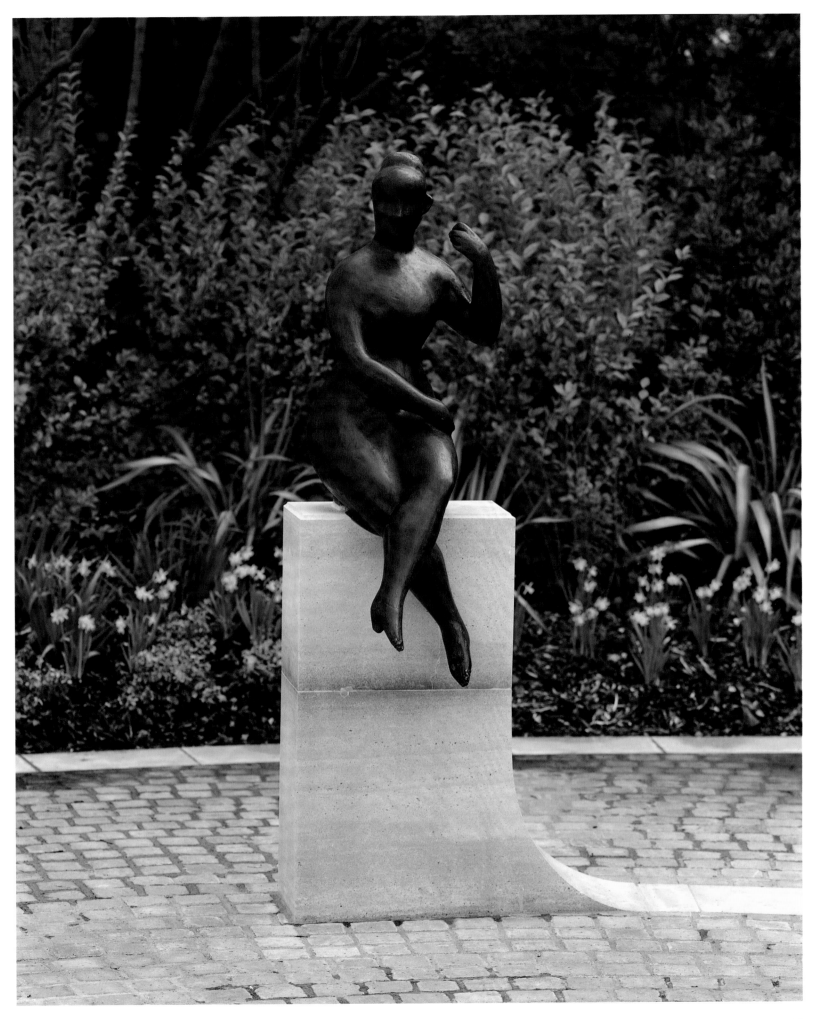

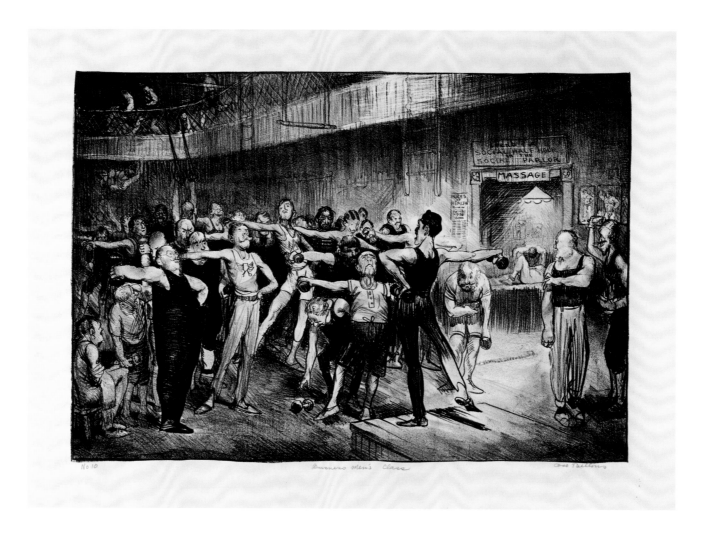

GEORGE BELLOWS

(Columbus, Ohio, 1882–1925)
Business-men's Class, Y.M.C.A., 1916
Lithograph, 11½ x 17¼ (29.2 x 43.8)
Edition of 64
Donated by Babette and Carmel Cohen

WILLIAM EGGLESTON

(Memphis, Tennessee, 1939)
Untitled (Adyn and Jasper next to
car), 1970; printed 1999
Dye transfer print, 20 x 24 (61 x 76.2)
Edition of 15
Donated by the Eggleston Artistic
Trust and Cheim & Read, New York

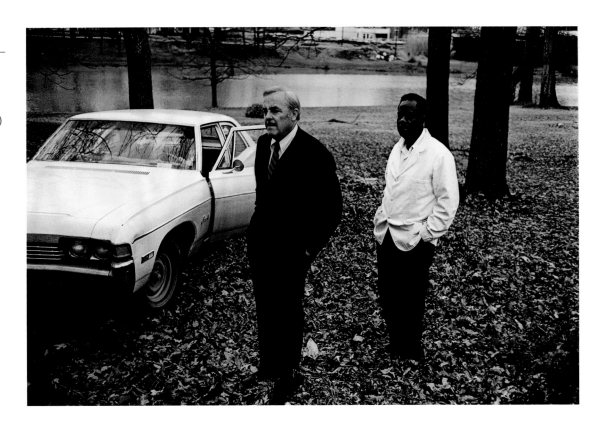

Untitled (boys in front of bush), 1970;
printed 1986
Dye transfer print, 18 x 23 (45.7 x 58.4)
Artist's proof
Donated by the Eggleston Artistic
Trust and Cheim & Read, New York

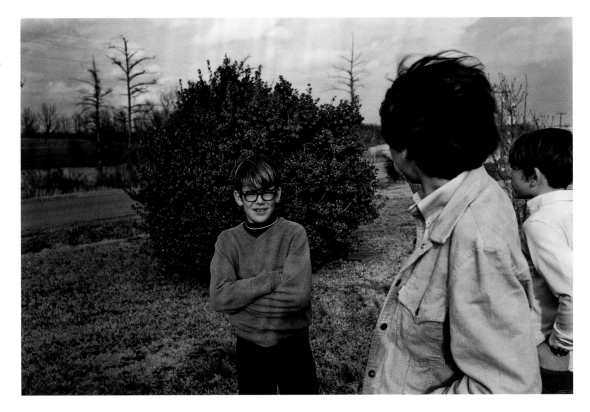

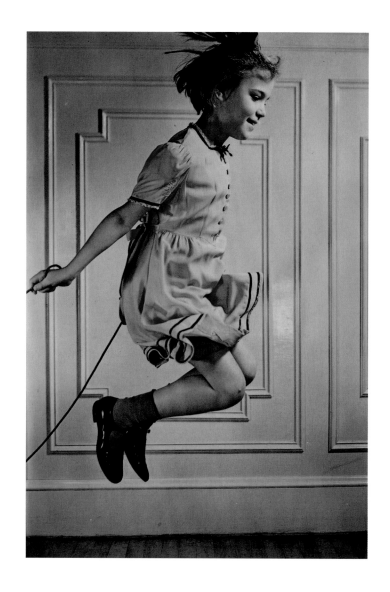

HAROLD E. EDGERTON

(Fremont, Nebraska, 1903–1990)
Jumping Girl, 1940
Dye transfer print, 14½ x 9⅝ (36.8 x 24.4)
Donated by Arlette and Gus Kayafas

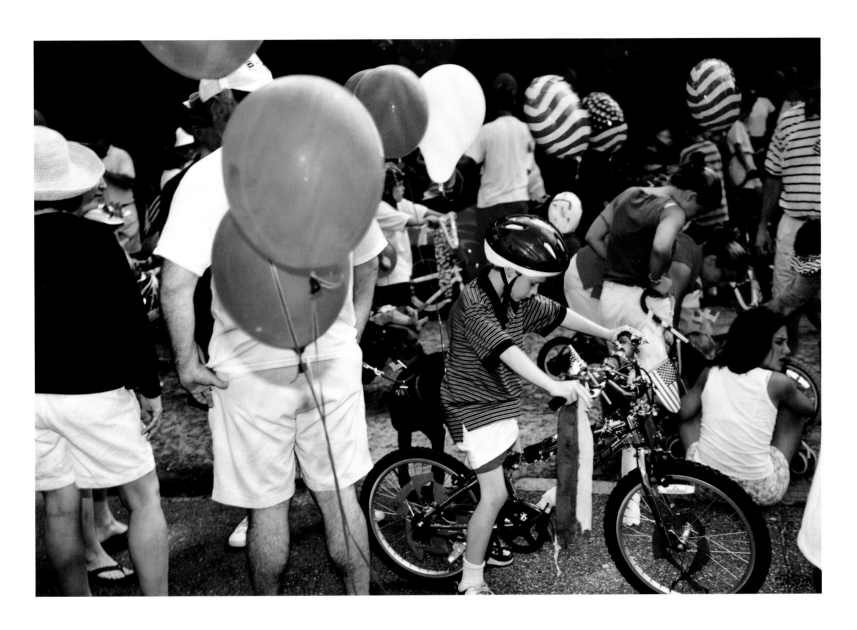

TINA BARNEY

(New York, 1945)
Fourth of July, 1999
C-print, 30 x 44 (76.2 x 111.8)
Donated by the artist and Janet Borden, Inc., New York

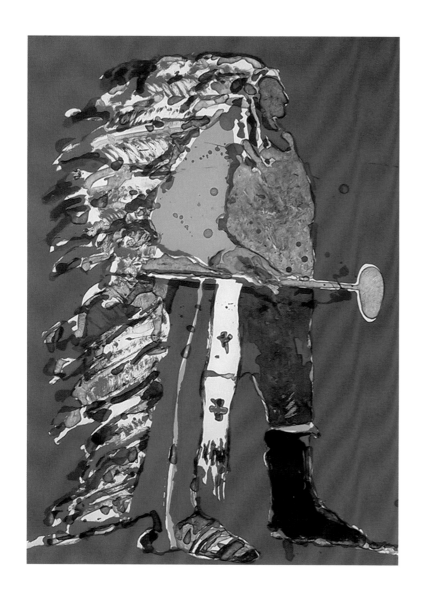 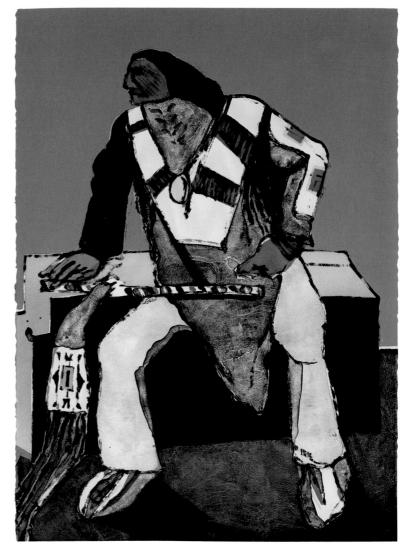

FRITZ SCHOLDER

(Breckenridge, Minnesota, 1937)
Indian Portrait with Tomahawk, 1975; Tamarind Institute,
Albuquerque, New Mexico
Lithograph, 30 x 22 (76.6 x 55.9)
Edition of 75
Donated by the artist

Another Deco Indian, 1978; Tamarind Institute, Albuquerque,
New Mexico
Lithograph, 30 x 22 (76.6 x 55.9)
Edition of 150
Donated by the artist

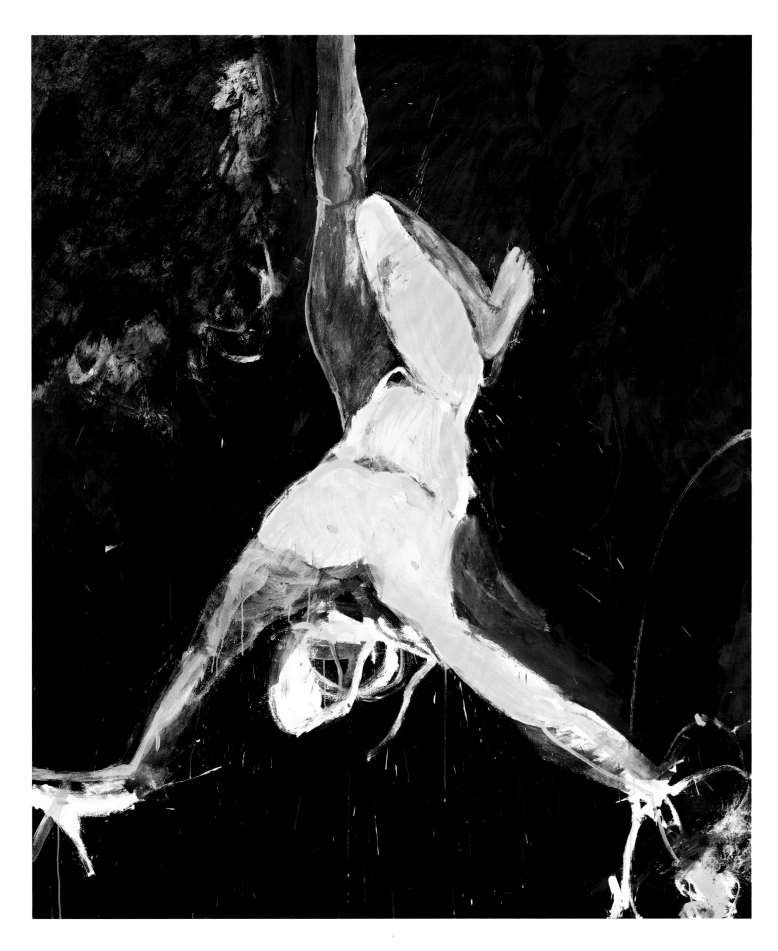

Martyr #4, 1993
Acrylic and oil on canvas, 80 x 68 (203.2 x 172.7)
Donated by the artist

GEORGE CONDO

(Concord, New Hampshire, 1957)
Untitled, 1986
Ink, 10 x 7¼ (25.4 x 18.4)
Donated by Barbara Gladstone

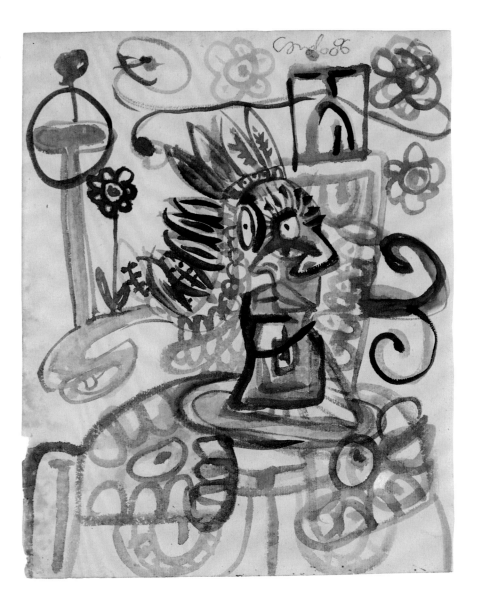

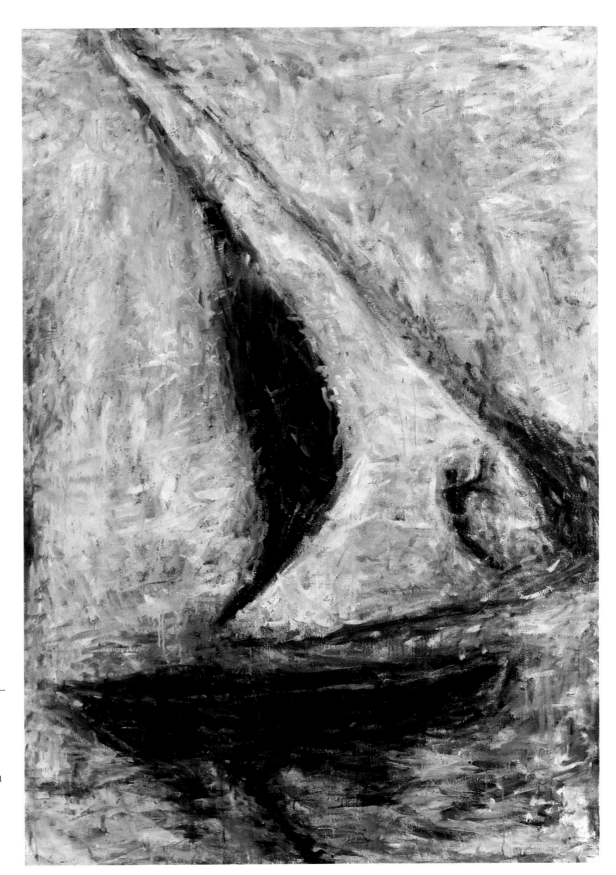

SUSAN ROTHENBERG

(Buffalo, New York, 1945)
Boat/Man, 1981–82
Oil on canvas, 58 x 42
(147.3 x 106.7)
Donated by Emily Fisher Landau

PROVENANCE

Willard Gallery, New York; Donald B.
Marron Art Collection, New York;
Collection of Robert Mnuchin, New
York; Jeffrey Hoffeld & Co., New York

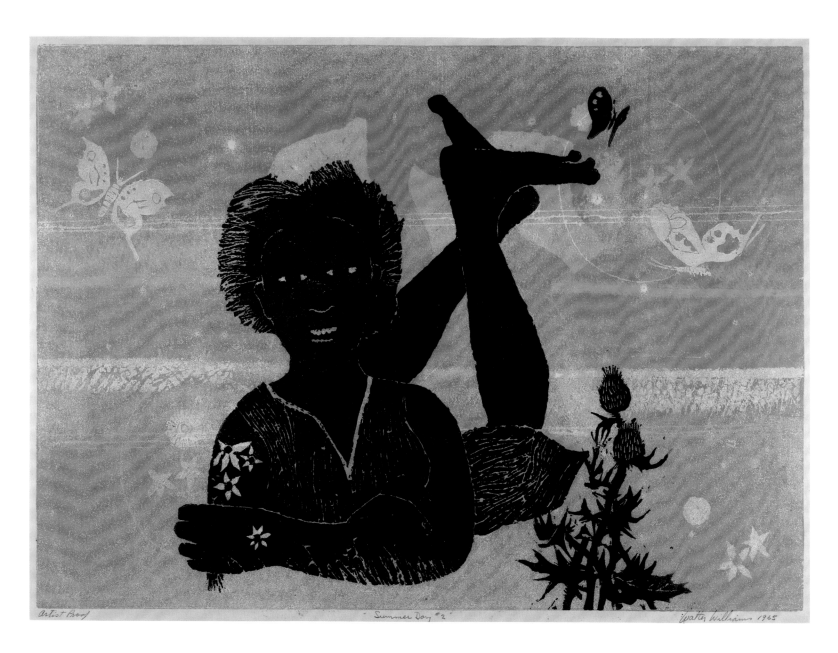

WALTER WILLIAMS

(Brooklyn, New York, 1920–1998)
Summer's Day #2, 1965
Woodcut, 29 x 36 (73.7 x 91.4)
Artist's proof
Donated by the Harmon and Harriet Kelley Collection of African
American Art

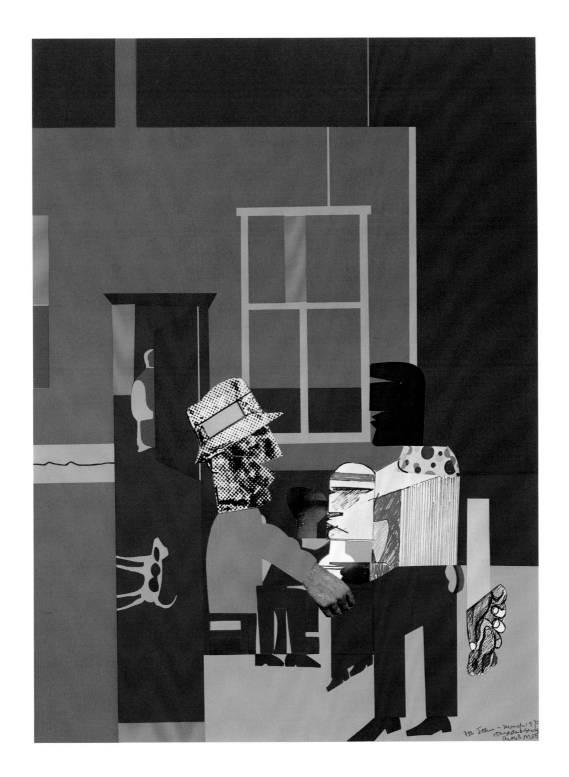

ROMARE BEARDEN

(Charlotte, North Carolina, 1911–1988)
Carolina Blue, 1969
Silkscreen collage, 23¾ x 17¾ (60.3 x 45.1)
Artist's proof
Donated by the Collection of Joan and Alan Washburn

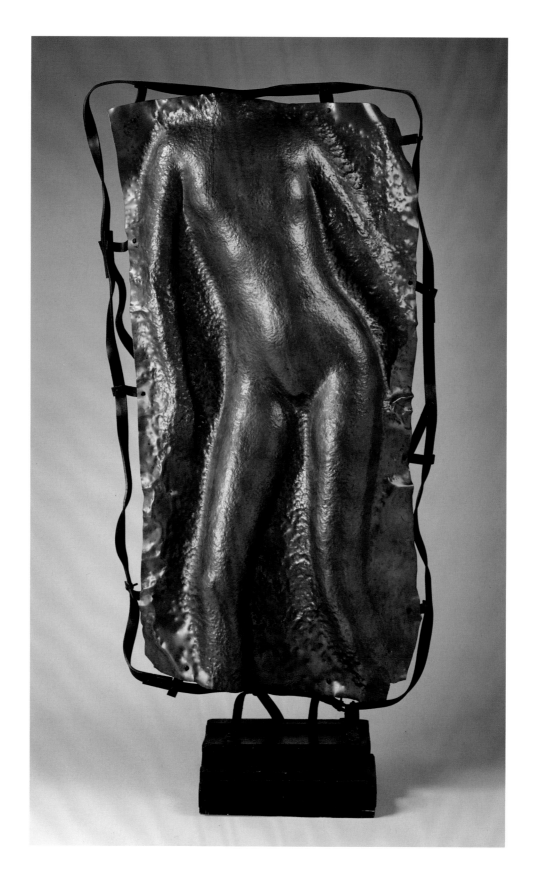

SAUL BAIZERMAN

(Vitebsk, Republic of Belarus,
Russia, 1889–1957)
Nocturne, c. 1954–55
Copper, 63½ x 33 x 8½
(161.3 x 83.8 x 21.6)
Donated by Cynthia Hazen Polsky

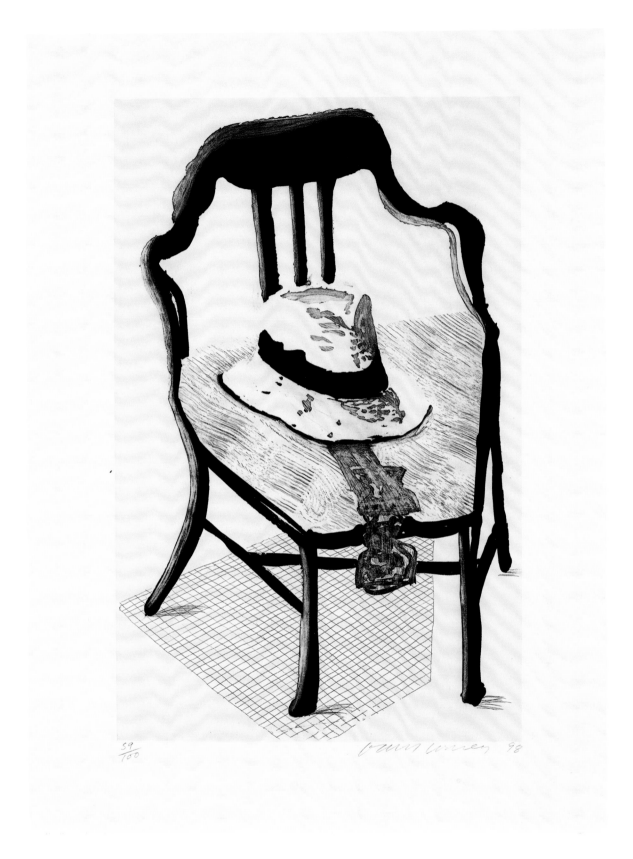

59/100

David Hockney 98

DAVID HOCKNEY

(British: Bradford, England, 1937)
Panama Hat with a Bow Tie on a Chair, 1998
Etching and aquatint, 23½ x 15½ (59.7 x 39.4)
Edition of 100; printed by Maurice Payne, New York
Donated by Sheila W. and Richard J. Schwartz

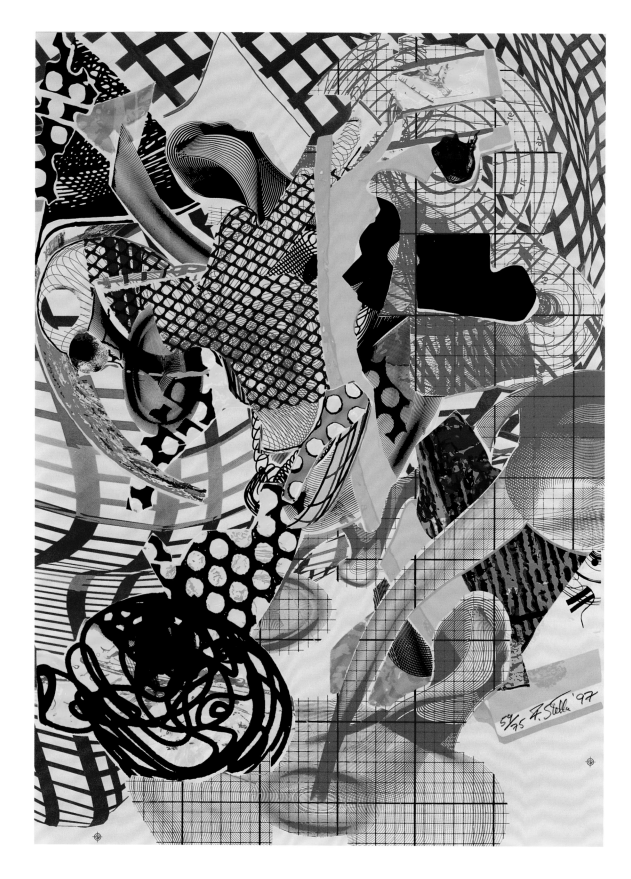

FRANK STELLA

(Malden, Massachusetts, 1936)
Coxuria, 1997
Screenprint, 30 x 22 (76.2 x 55.9)
Edition of 75; printed by Tyler Graphics Ltd., Mount Kisco, New York
Donated by Sheila W. and Richard J. Schwartz

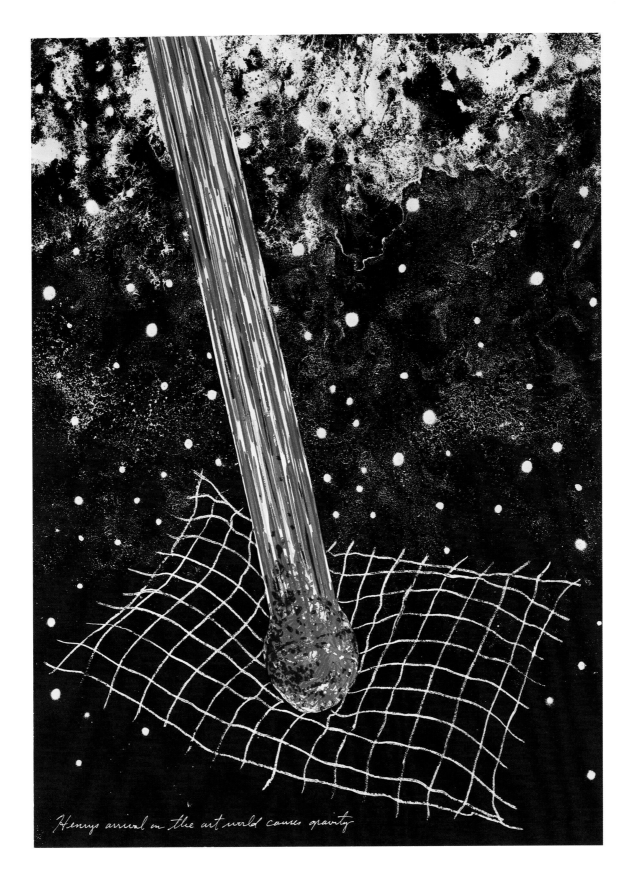

Henry's arrival on the art world causes gravity

JAMES ROSENQUIST

(Grand Forks, North Dakota, 1933)
Henry's Arrival on the Art World Causes Gravity, 1997
Lithograph, 30 x 22 (76.2 x 55.9)
Edition of 75; printed by Universal Limited Art Editions, Inc., West Islip, New York
Donated by Sheila W. and Richard J. Schwartz

DAVID SALLE

(Norman, Oklahoma, 1952)
Paper Lanterns, 1998
Intaglio, 16 x 10½ (40.6 x 26.7)
Edition of 75; printed by Hampton
Editions, Ltd., Sag Harbor, New York
Donated by Sheila W. and Richard J.
Schwartz

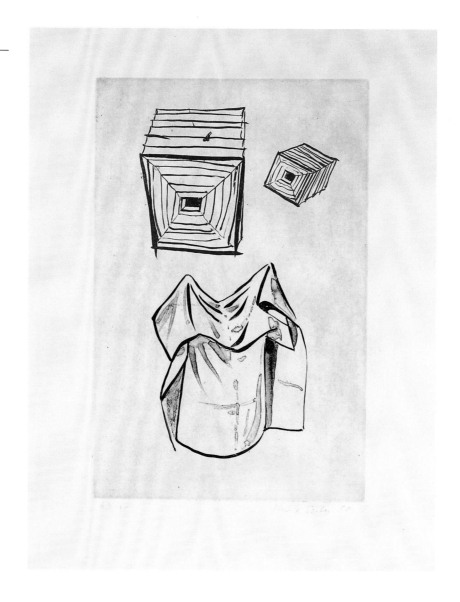

LOUISE BOURGEOIS

(Paris, 1911)
A Flower in the Forest, 1997
Lithograph, 22 x 30 (55.9 x 76.2)
Edition of 75; printed by Solo Impressions,
New York
Donated by Sheila W. and Richard J.
Schwartz

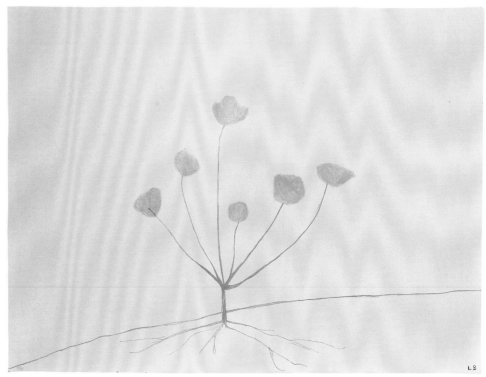

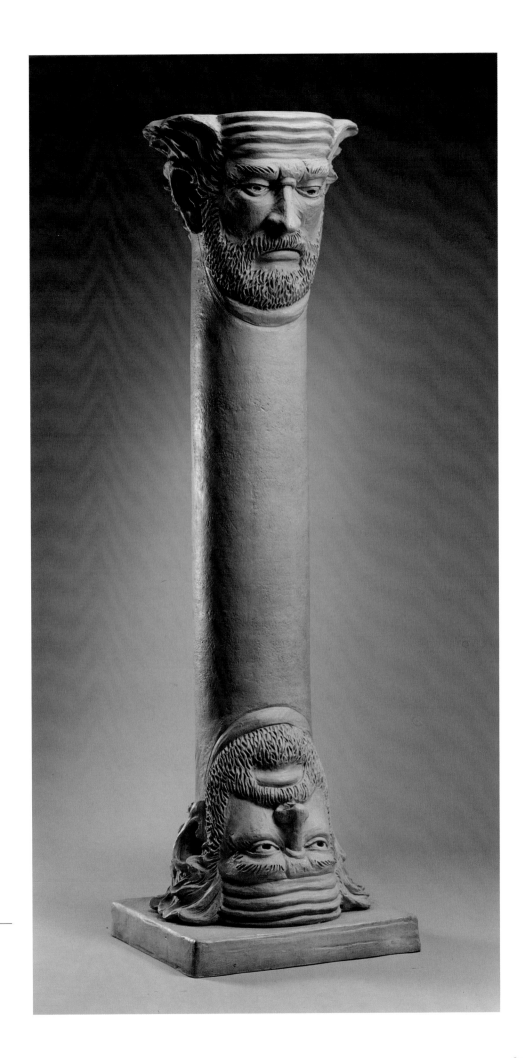

ROBERT ARNESON

(Benecia, California, 1930–1992)
Critical Appraisal, 1992
Bronze, 78 x 24 x 23 (198.1 x 61 x 58.4)
Edition of three
Donated by Sandra Shannonhouse

ROBERT RAUSCHENBERG

(Port Arthur, Texas, 1925)
Homage to Frederick Kiesler, 1966
Offset lithograph, 34⅞ x 23 (88.6 x 58.4)
Edition of 200
Donated by Barbara Schwartz

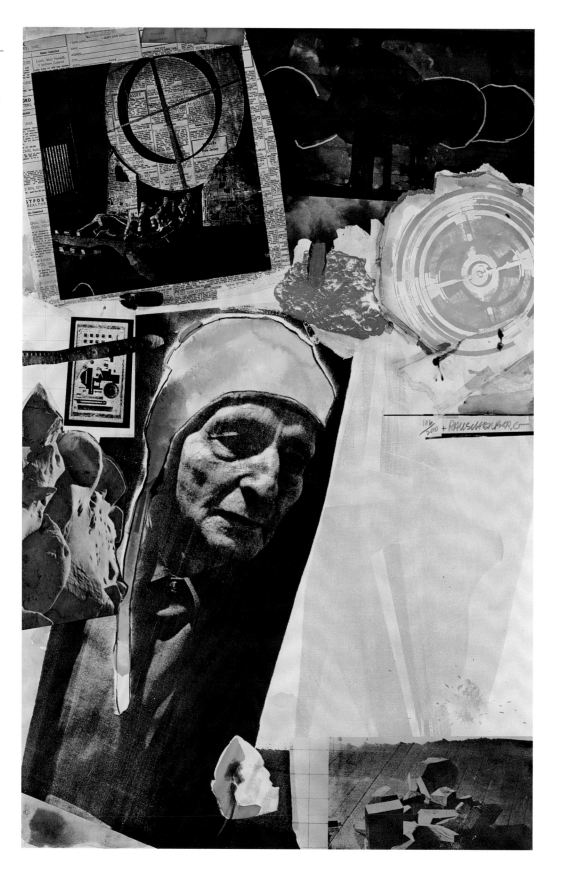

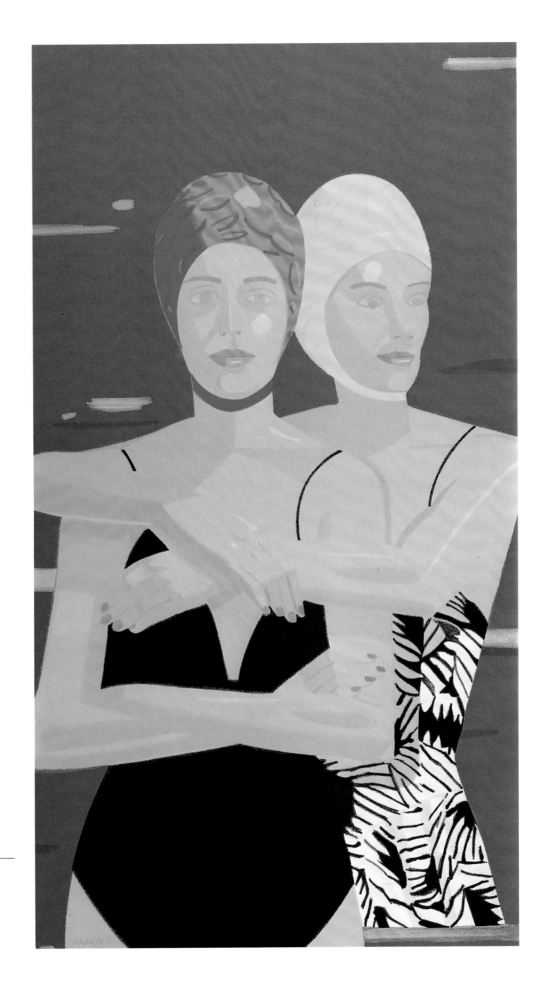

ALEX KATZ

(New York, 1927)
Eleuthera, 1999; Brand X, New York
Silkscreen, 48 x 26¾ (121.9 x 67.9)
Artist's proof
Donated by the artist

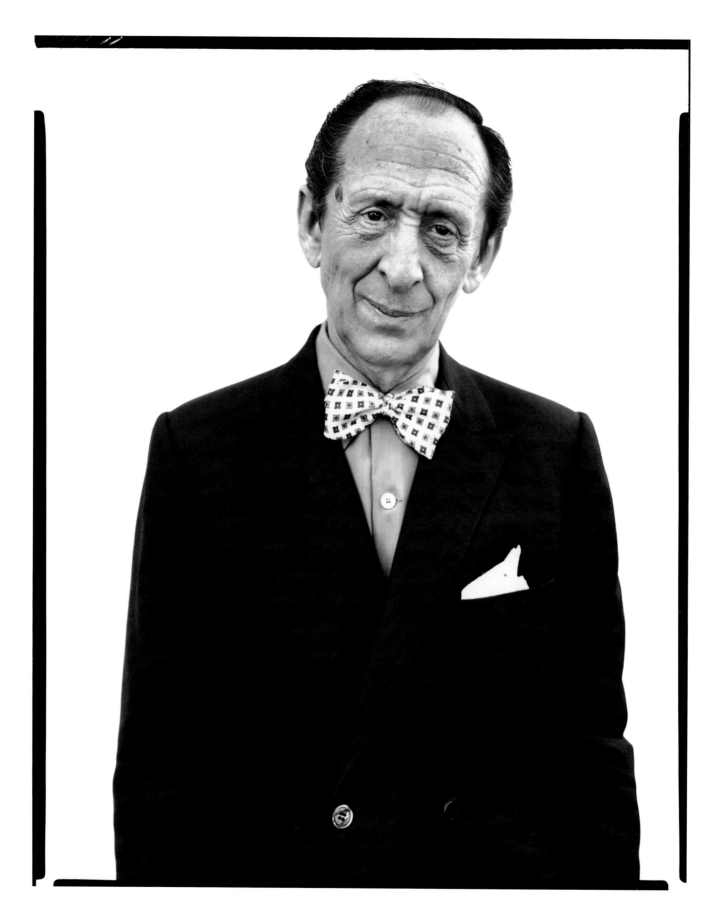

RICHARD AVEDON

(New York, 1923)
Vladimir Horowitz, Pianist, 1975
Vintage gelatin silver print, 38 x 30 (96.5 x 76.2)
Donated by the artist

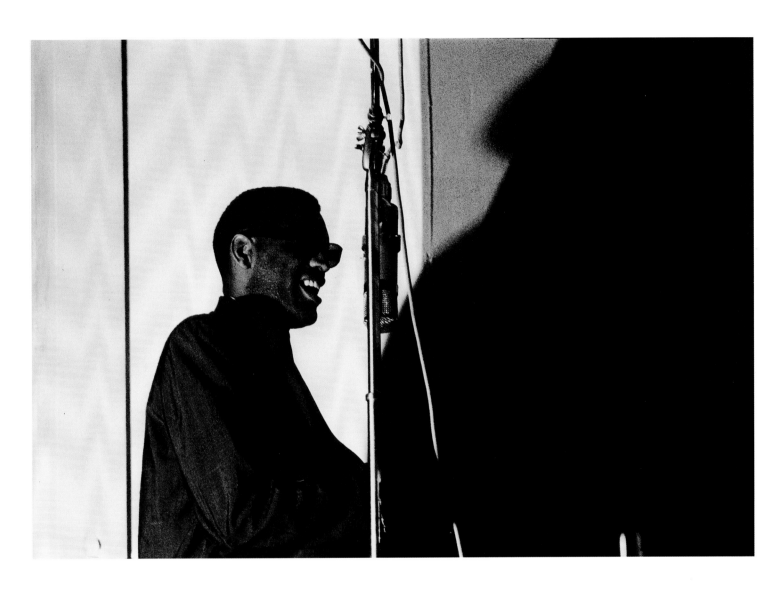

LEE FRIEDLANDER

(Aberdeen, Washington, 1934)
Ray Charles, 1958; printed 2001
Iris print, 15½ x 22 (39.4 x 55.9)
Purchased with funds donated by The Brown Foundation, Inc.,
Houston

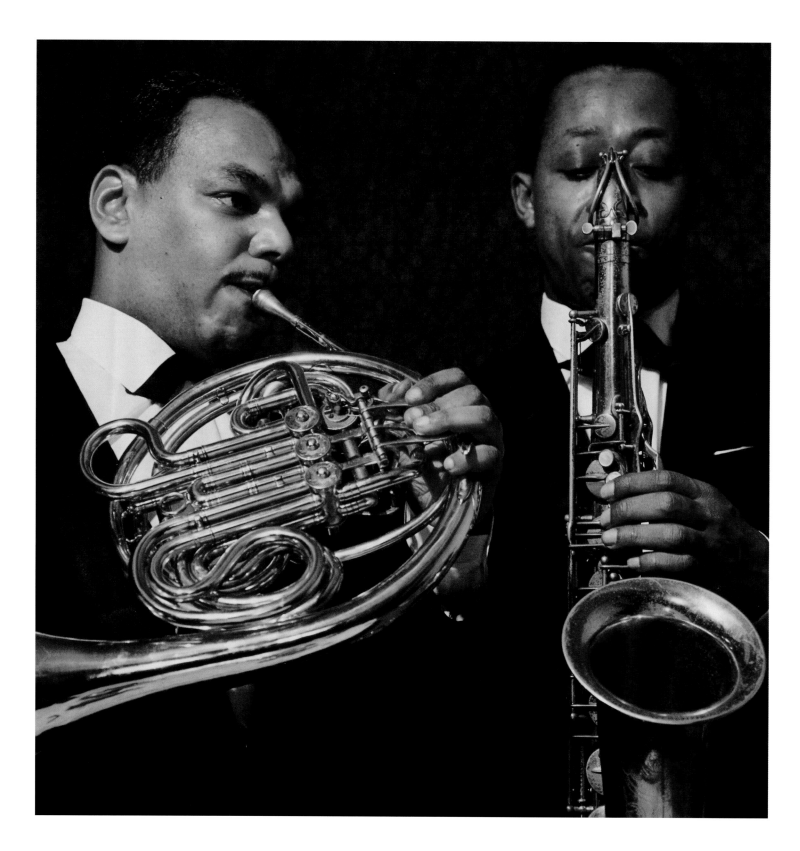

LEE FRIEDLANDER

(Aberdeen, Washington, 1934)
Julius Watkins and Charlie Rouse, 1950s; printed 2000
Iris print, 22½ x 22 (57.2 x 55.9)
Purchased with funds donated by The Brown Foundation, Inc.,
Houston

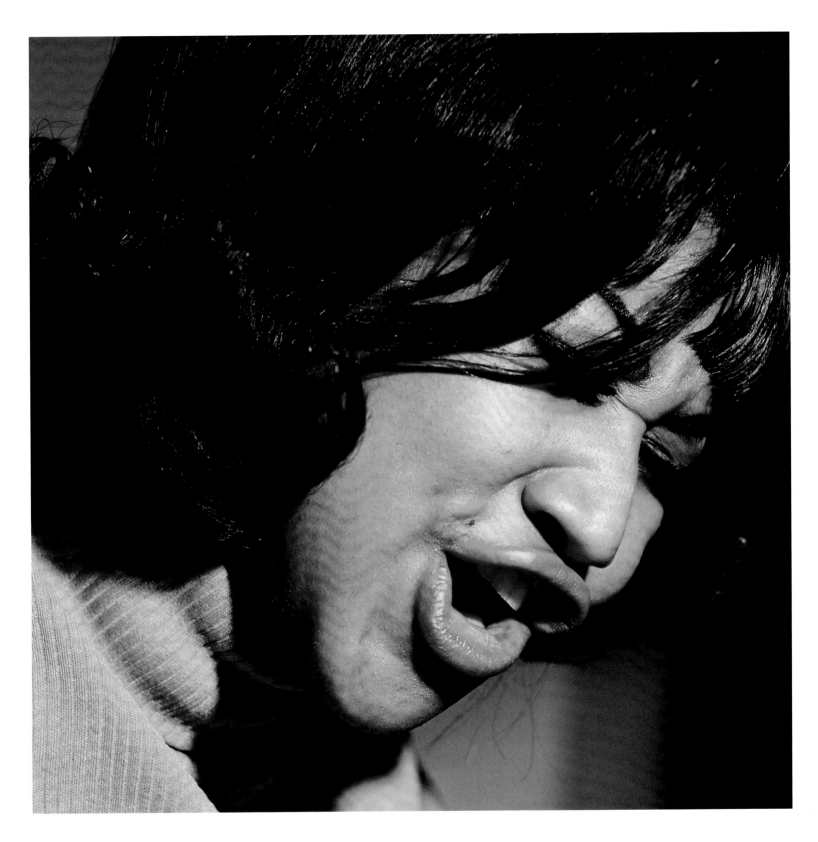

Aretha Franklin, 1968; printed 2000
Iris print, 34 x 34 (86.4 x 86.4)
Donated by the artist

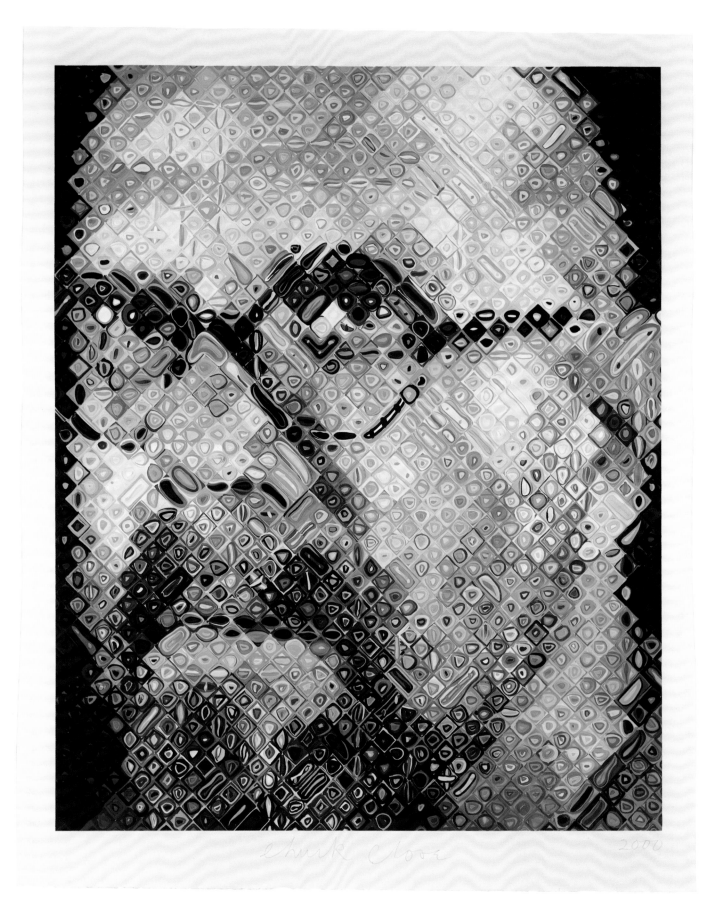

CHUCK CLOSE

(Monroe, Washington, 1940)
Self Portrait, 2000; Pace Editions, Inc., New York
Silkscreen, 65½ x 54⅛ (166.4 x 138.7)
Edition of 80; printed by Brand X, New York
Donated by the artist and Pace Prints, New York

Our Perspective

Many artists who found a new life and inspiration in the lands of America brought with them eyes educated abroad. They worked alongside generations of artists who sought stimulation in countries where the famous artists of the past created their masterpieces. Yet their imagery, whether borrowed from famous sources or based upon their own foreign experiences, has an underlying aspect that is definitely American. The shared past that most Americans have with other nationalities is a powerful motivation in their creativity.

A different kind of perspective has fostered the creation of art that emanates from intense curiosity about the very familiar and the barely visible. Unconventional subject matter in art has evolved from examining visual phenomena with newly developed techniques, or reprocessing the signs, images, and materials of art itself. The influence of the moving image in this century has been a pivotal element in transforming the point of view of what art is.

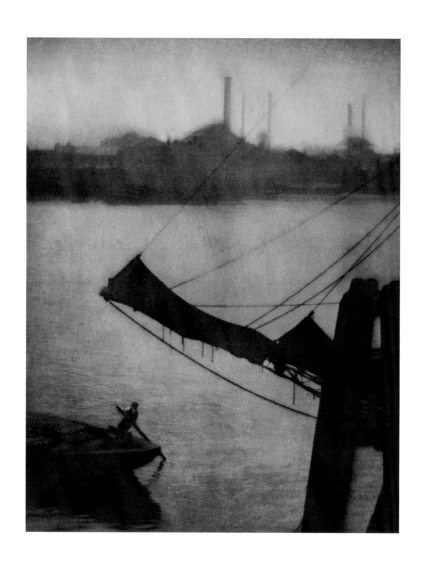 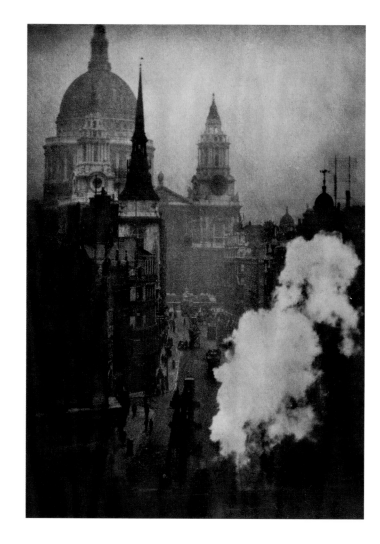

ALVIN LANGDON COBURN

(Boston, 1882–1966; immigrated to Great Britain)
Scenes from *London*, Duckworth & Co., 1909
Photogravures, 8¼ x 6⅜ (21 x 16.2) each
Donated by George Eastman House, International Museum of
Photography and Film, and Kodak Professional, a division of
Eastman Kodak Company, Rochester, New York

Wapping, 1904

St. Paul's from Ludgate Circus, 1905

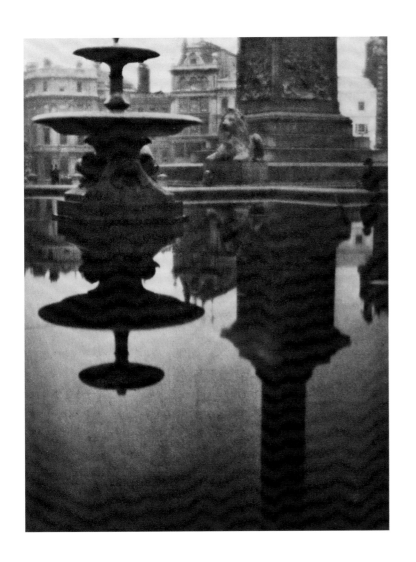 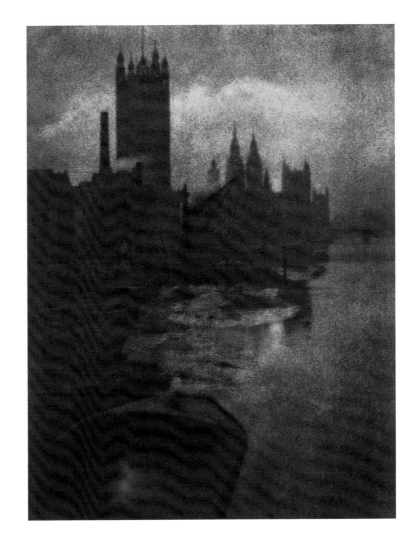

Trafalgar Square, c. 1907

Houses of Parliament, c. 1907

ANDRÉ KERTÉSZ

(Budapest, Hungary, 1894–1985)
Paris Scenes, 1925–29
Gelatin silver prints, 7½ x 9½ or
9½ x 7½ (19 x 24.1 or 24.1 x 19)
Donated by Harriette and Noel Levine

Café du Dôme, 1928

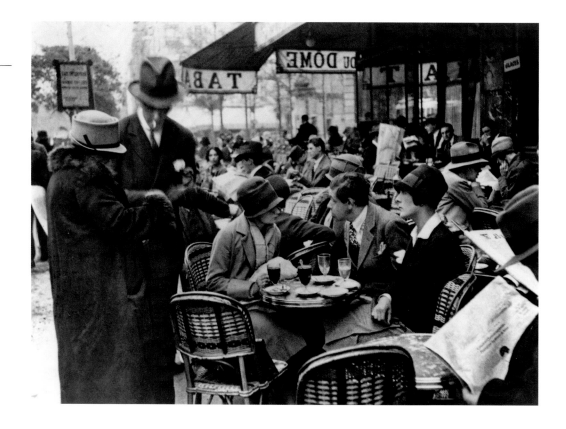

A Gentleman, 1926

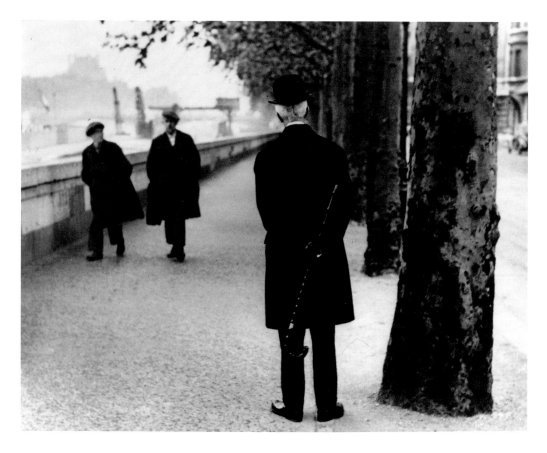

Boulevard Malesherbes, 1925

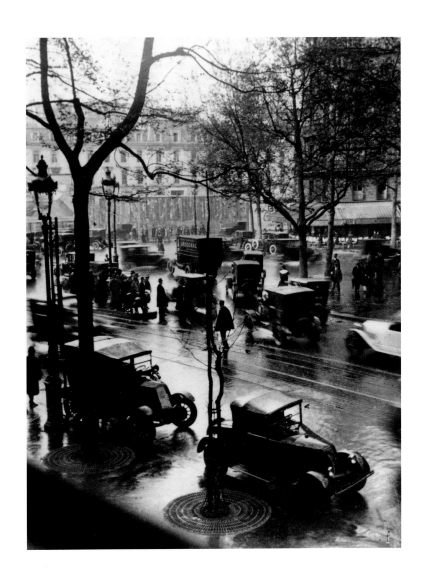

Eiffel Tower, 1929

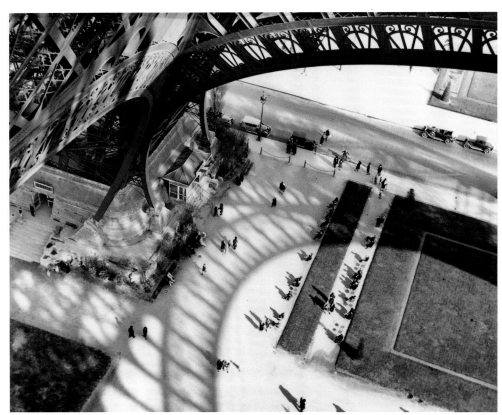

ANDRÉ KERTÉSZ

(Budapest, Hungary, 1894–1985)
After School in the Tuileries, Paris, 1930
Gelatin silver print, 5½ x 9½ (14 x 24.1)
Donated by Harriette and Noel Levine

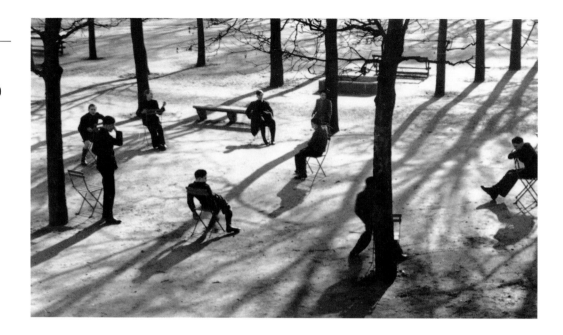

The Big Pond in the Tuileries, Paris, 1963
Gelatin silver print, 7½ x 9½ (19 x 24.1)
Donated by Harriette and Noel Levine

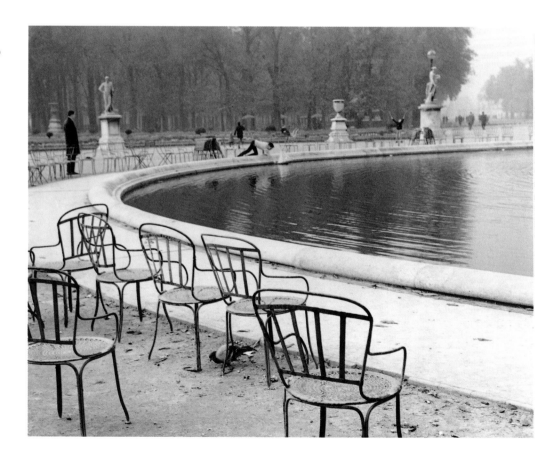

JENNIFER BARTLETT

(Long Beach, California, 1941)
In the Garden #118, 1982; the artist and Simca Print Artists, Inc.,
New York
Silkscreen, 29 x 38 (73.7 x 96.5)
Edition of 50
Donated by Eden Rafshoon

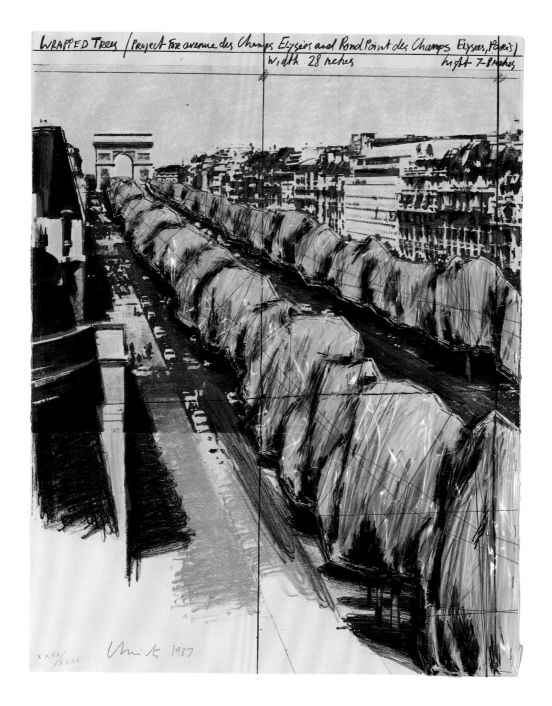

CHRISTO

(Gabrovo, Bulgaria, 1935)
Wrapped Trees, Project for the Avenue des Champs-Elysees, Paris.
Lithograph with collage, 1987; Torsten Lilja, Stockholm
Transparent polyethylene, thread, staples, and felt marker additions,
27 x 22 (68.6 x 55.9)
Edition of 200; printed by Landfall Press, Chicago
Donated by Eileen and Peter Norton

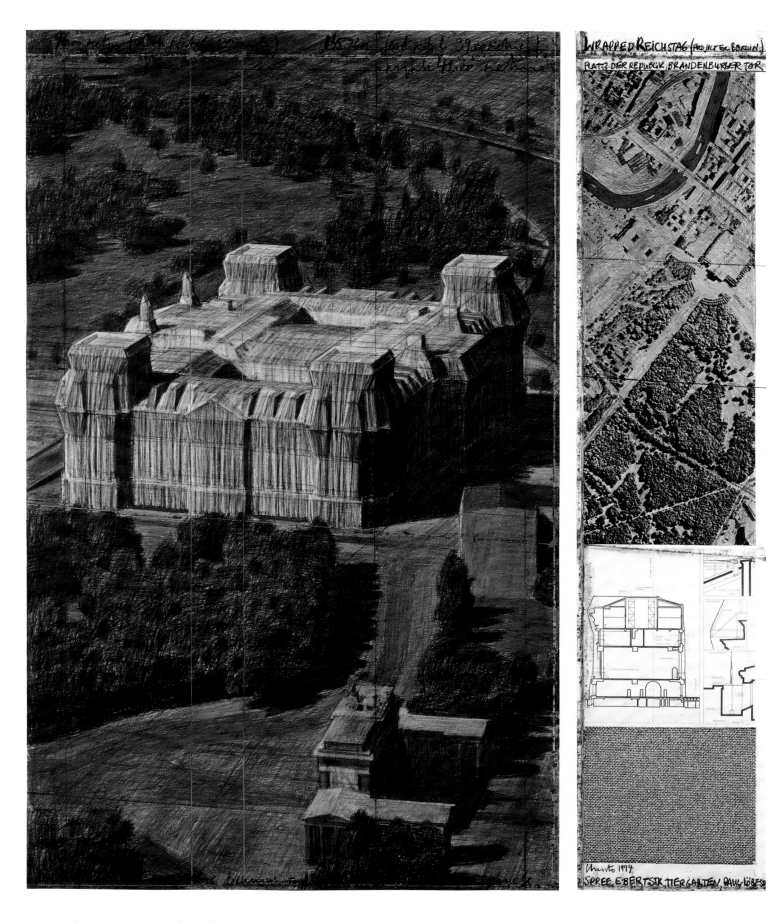

Wrapped Reichstag, Project for Berlin. Drawing, 1994, in two parts.
Pencil, charcoal, pastel, wax crayon, fabric sample, aerial photograph, and
technical data, 65 x 42 and 65 x 15 (165.1 x 106.6 and 165.1 x 38.1)
Donated by Agnes Gund and Daniel Shapiro

FRANK STELLA

(Malden, Massachusetts, 1936)
Hockenheim, 1981
Mixed media on Tycore, 72 x 81 x 14 (182.9 x 205.7 x 35.6)
Donated by Douglas S. Cramer

PROVENANCE
Collection of the artist

LARRY RIVERS

(Bronx, New York, 1925)
Kinko the Nymph Bringing Happy Tidings, 1974
Acrylic on canvas, 78 x 108 x 2½ (198.1 x 274.3 x 6.3)
Donated by Collection of Mr. and Mrs. Graham Gund

PROVENANCE
Marlborough Gallery, New York

FRANK STELLA

(Malden, Massachusetts, 1936)
Meknes, 1964
Fluorescent alkyd on canvas, 77 x 77 (195.6 x 195.6)
Donated by Philip Johnson

PROVENANCE

Leo Castelli Gallery, New York; Dr. and Mrs. Eugene A. Eisner; Sotheby's, New York

JULIAN SCHNABEL

(New York, 1951)
Untitled, 1982
Oil on paper, 44 x 38 (111.8 x 96.5)
Donated by David McKee

PROVENANCE
Mary Boone Gallery, New York

RICHARD SERRA

(San Francisco, 1939)
HREPPHOLAR VII from the *Afangar Icelandic Series*, 1991; Gemini
G.E.L., Los Angeles
Intaglio, 31¾ x 42 (80.6 x 106.7)
Edition of 35
Donated by Eileen and Peter Norton

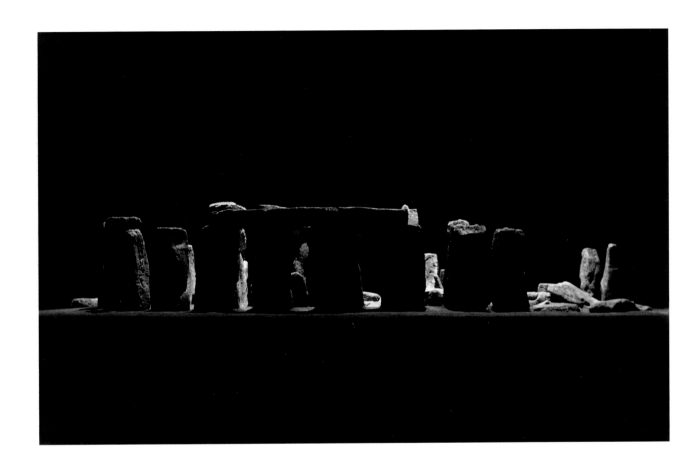

HAROLD E. EDGERTON

(Fremont, Nebraska, 1903–1990)
Stonehenge, 1944
Gelatin silver print, 11¼ x 17⅝ (28.6 x 44.8)
Donated by Arlette and Gus Kayafas

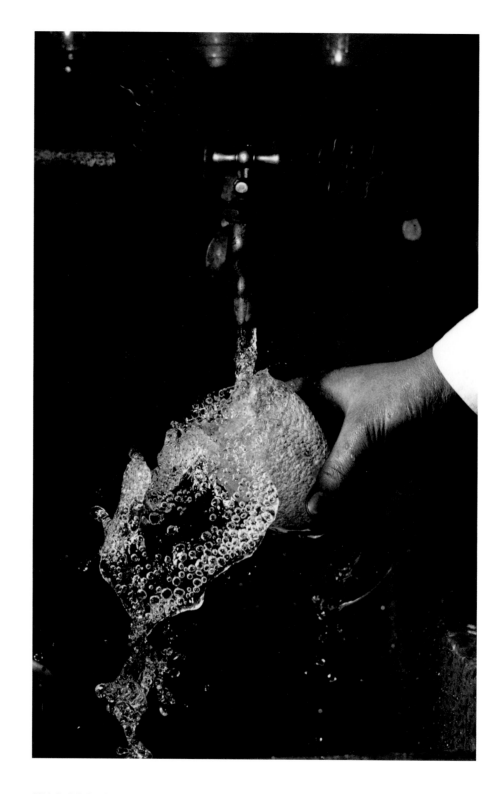

HAROLD E. EDGERTON

(Fremont, Nebraska, 1903–1990)
Water into Goblet, 1934
Gelatin silver print, 12⅜ x 8 (31.4 x 20.3)
Donated by Arlette and Gus Kayafas

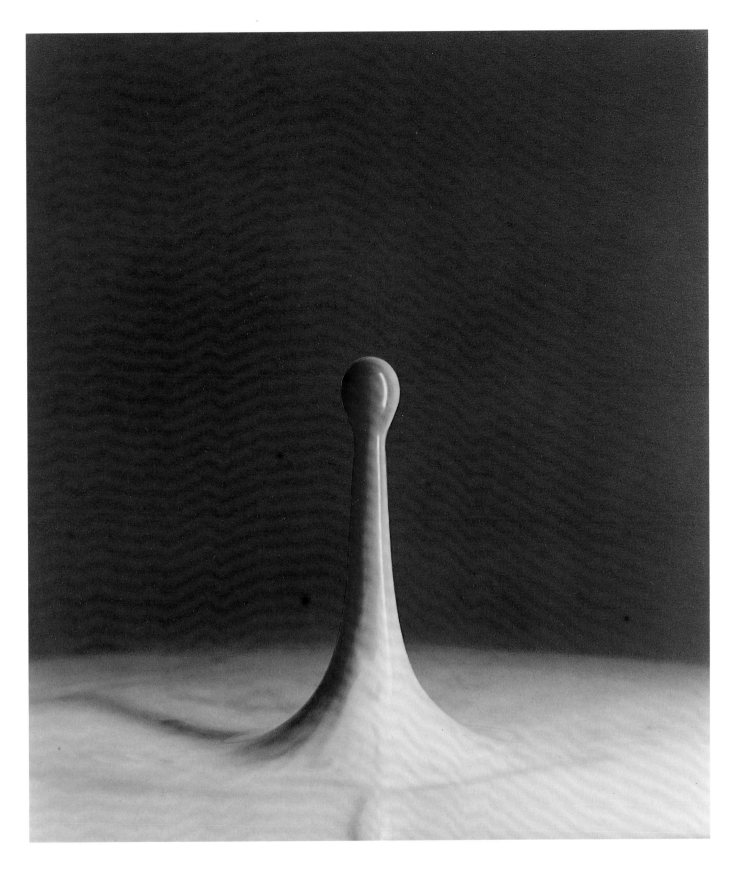

Cranberry Juice Dropping into Milk, 1960
Dye transfer print, 15¾ x 13⅞ (40 x 35.2)
Donated by Arlette and Gus Kayafas

WILLIAM WEGMAN

(Holyoke, Massachusetts, 1943)
About Face, 1993
Two Polaroids, 24 x 20 (61 x 50.8) each
Donated by Christine Burgin, William
Wegman, and Pace/MacGill Gallery,
New York

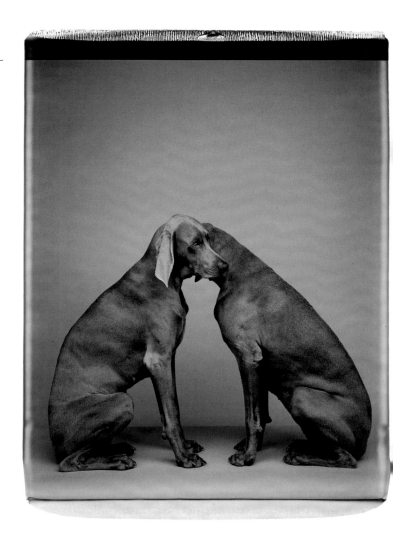

Little Red Riding Hood, 1998
Four Polaroids, 24 x 20 (61 x 50.8) each
Purchased with funds donated by the
Junior Committee of the Friends of Art
and Preservation in Embassies

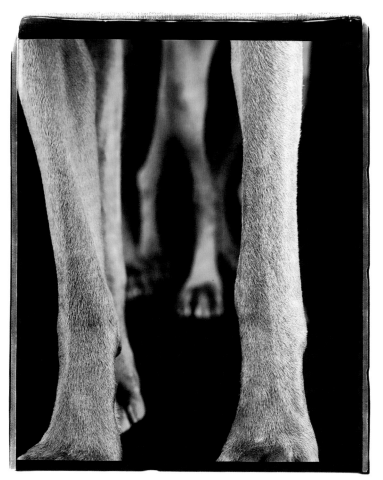

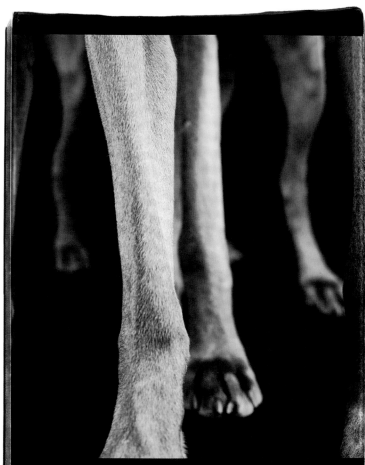

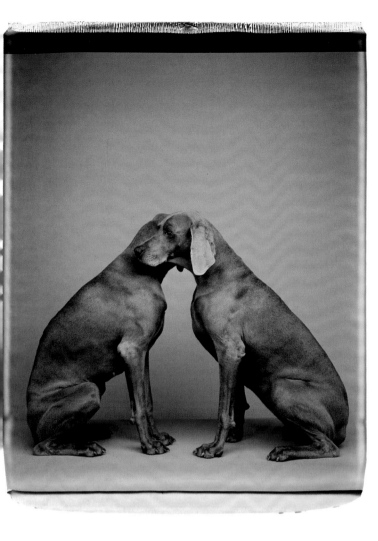

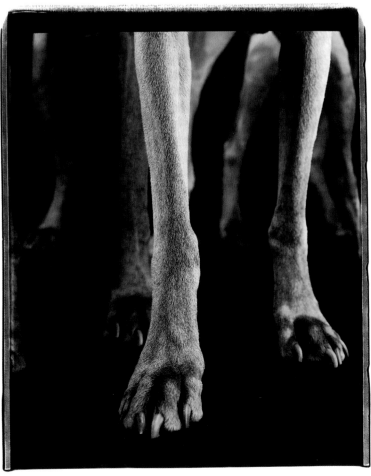

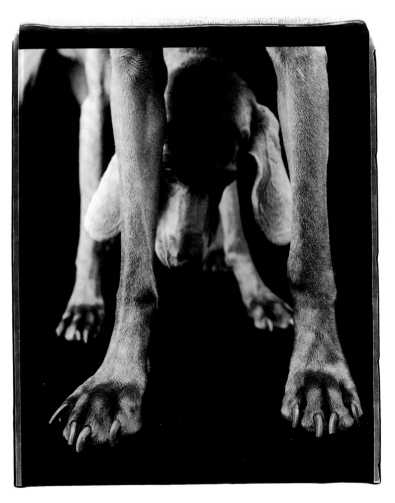

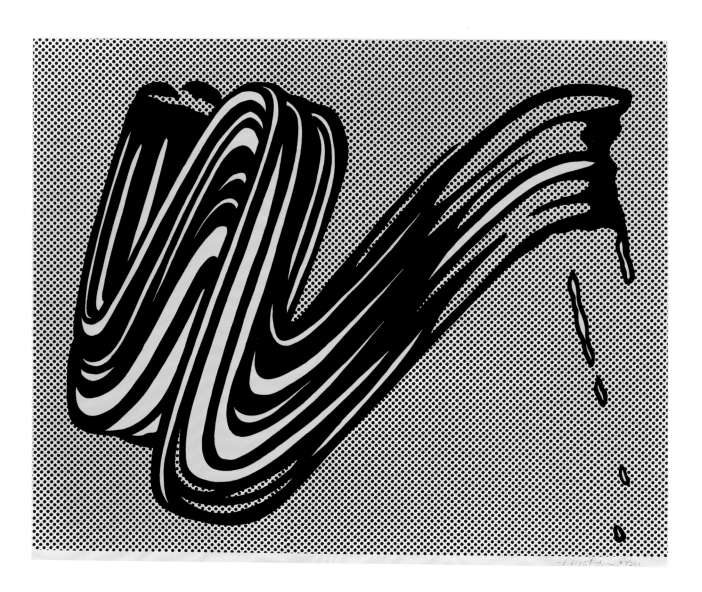

ROY LICHTENSTEIN

(New York, 1923–1997)
Brushstroke, 1965; Gemini G.E.L., Los Angeles
Screenprint, 22³/₁₆ x 28½ (56.5 x 72.4)
Edition of 280
Donated by Rosalind Jacobs, from the Rosalind and Melvin Jacobs
Collection

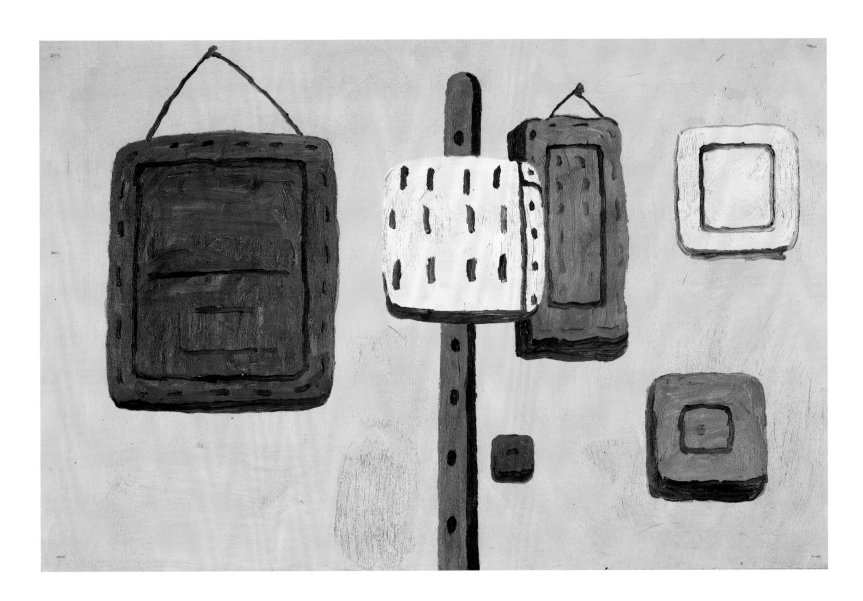

PHILIP GUSTON

(Montreal, 1913–1980)
Untitled, 1969
Oil on wood, 26 x 40 (66 x 101.6)
Donated by Musa and Tom Mayer

PROVENANCE
Collection of the artist

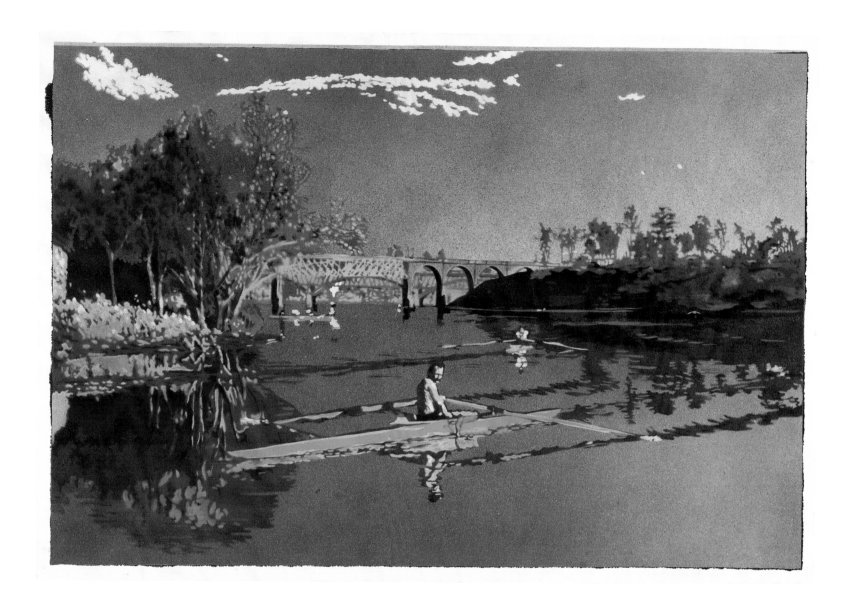

JOHN CLEM CLARKE

(Bend, Oregon, 1937)
Eakins—Max Schmitt in a Single Scull, 1968
Oil on canvas, 37 x 55 (94 x 139.7)
Donated by Barbara Schwartz

PROVENANCE
Jill Kornblee Gallery, New York

Our Country

"America the Beautiful" is not an overstatement. Even in the twenty-first century, the vision of an untouched, spectacular land remains. However, closer examination of our surroundings has also focused upon their often brutal transformation. The dominance of urban spaces, both exterior and interior, has widened the vocabulary of our environment. Of all the artists who have depicted this multi-dimensional world, photographers have most notably used their medium to make memorable the awesome as well as the cruel.

Attention to the variety of elements that envelop us is sharpened by the choices artists make. They celebrate our country in comforting objects, such as an old-fashioned kitchen stove, or in dynamic ones, such as a streamlined office. All over America, signs showing hamburgers or the perpetually popular American Beauty rose have become icons of our homeland.

MAUDE SCHUYLER CLAY

(Greenwood, Mississippi, 1953)
*Church and Tree, Choctaw, Washington
County, Mississippi,* 1997
Sepia-toned gelatin silver print, 16 x 20
(40.6 x 50.8)
Donated by the artist

*Dog on a Log, Sandy Bayou, near Glendora,
Tallahatchie County, Mississippi,* 1993
Sepia-toned gelatin silver print, 16 x 20
(40.6 x 50.8)
Donated by the artist

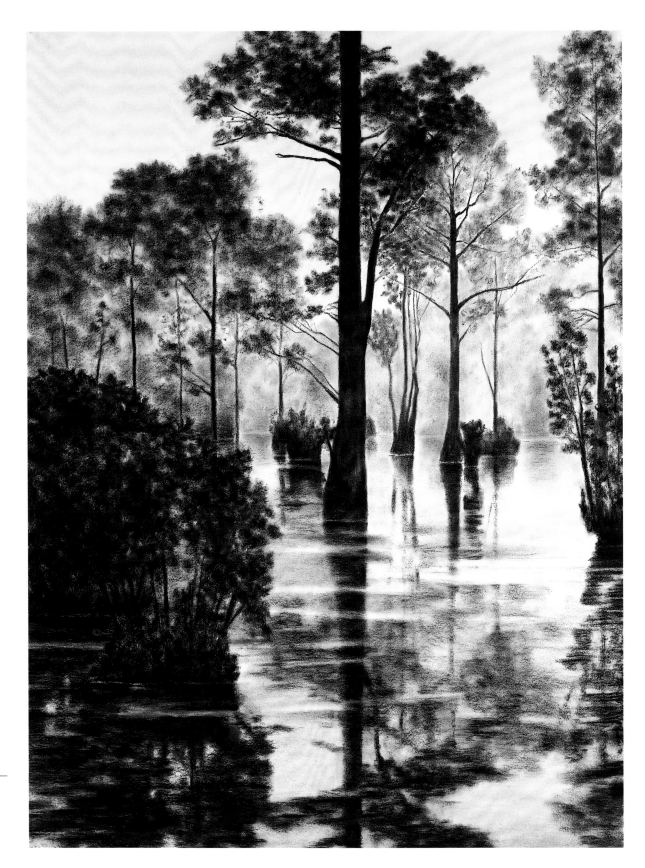

APRIL GORNIK

(Cleveland, Ohio, 1953)
Swamp Light, 2000
Charcoal, 50 x 38 (127 x 96.5)
Donated by Neda Young

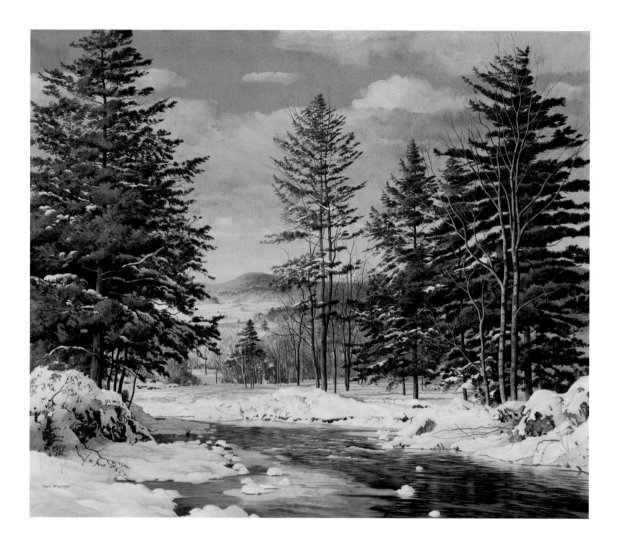

CARL WUERMER

(Munich, 1900–1983)
The Wintry River, c. 1935
Oil on canvas, 20 x 30 (50.8 x 76.2)
Donated by Richard T. York

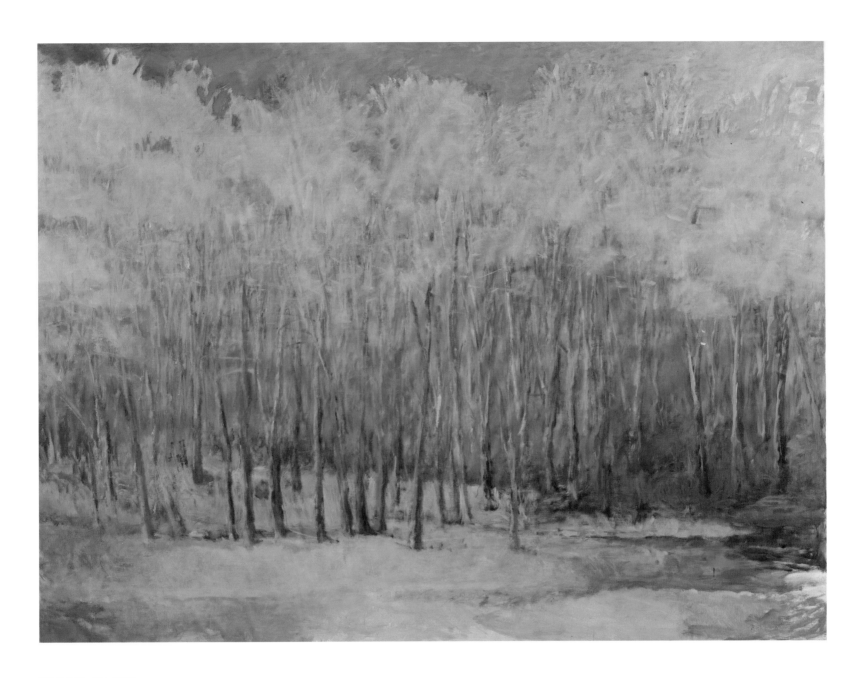

WOLF KAHN

(Stuttgart, 1927)
Stately and Bright, 2000
Oil on canvas, 80 x 108 (203.2 x 274.3)
Purchased with funds donated by The David and Lucile Packard
Foundation

ROBERT ADAMS

(Orange, New Jersey, 1937)
Pedestrian Access to the Ocean,
Nehalem Spit, Tillamook County,
Oregon, 1979
Gelatin silver print, 11 x 14
(27.9 x 35.6)
Donated on behalf of the artist by
Fraenkel Gallery, San Francisco

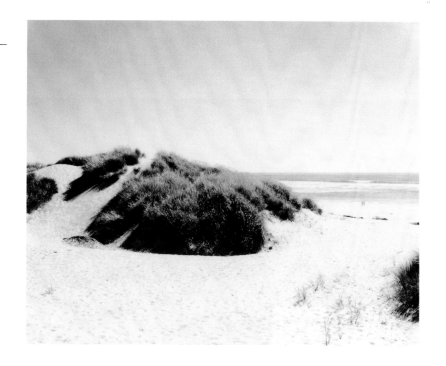

JANE FREILICHER

(Brooklyn, New York, 1924)
Late Afternoon, Southampton from
Why Draw a Landscape?, 1999; Crown
Point Press, San Francisco
Aquatint, etching, and drypoint,
12 x 15 (30.5 x 38.1)
Edition of 50
Purchased with funds donated by
The Brown Foundation, Inc.,
Houston

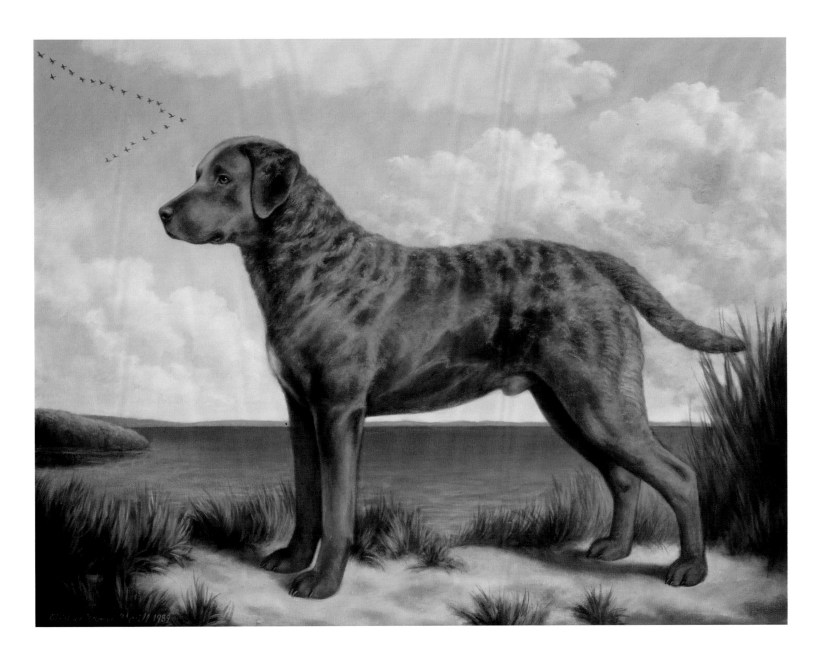

CHRISTINE MERRILL

(Baltimore, Maryland, 1963)
Chesapeake Bay Retriever, 1989
Oil on canvas, 24 x 31 (61 x 78.7)
Donated by Gilbert S. Kahn

APRIL GORNIK

(Cleveland, Ohio, 1953)
Stepped Waterfall from *Why Draw a Landscape?*, 1999; Crown Point Press, San Francisco
Gravure and aquatint, 7¼ x 6⅞ (18.4 x 17.5)
Edition of 50
Purchased with funds donated by The Brown Foundation, Inc., Houston

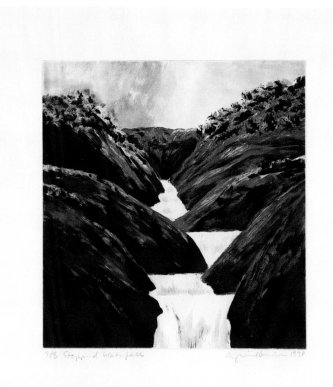

BRYAN HUNT

(Terre Haute, Indiana, 1947)
Small Cairn from *Why Draw a Landscape?*, 1999; Crown Point Press, San Francisco
Aquatint, etching, and drypoint, 11 x 9 (27.9 x 22.9)
Edition of 50
Purchased with funds donated by The Brown Foundation, Inc., Houston

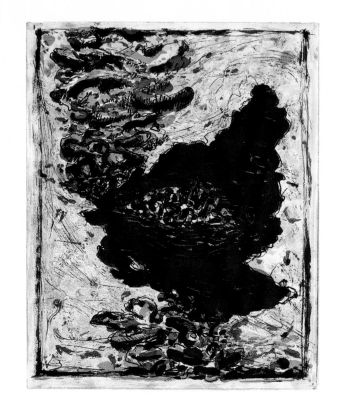

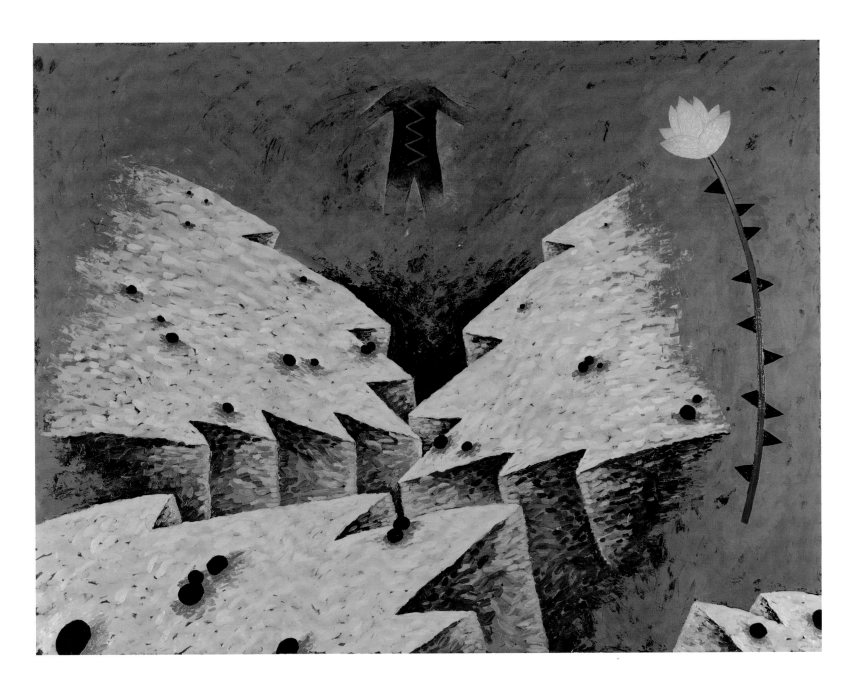

LOUISA CHASE

(Panama City, 1951)
Ravine, 1980
Oil on canvas, 72 x 96 (182.9 x 243.8)
Donated by Gerrit and Suydam Lansing

PROVENANCE

Robert Miller Gallery, New York

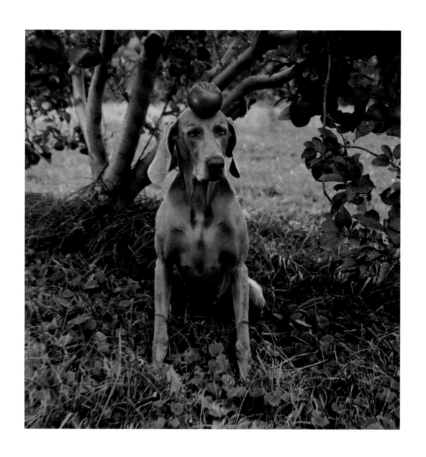 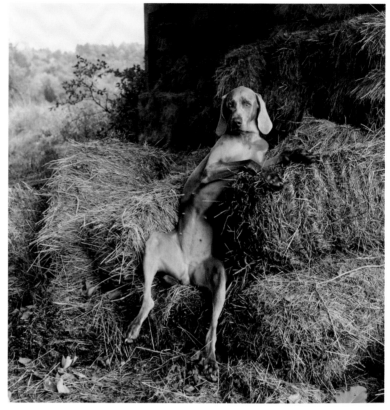

WILLIAM WEGMAN

(Holyoke, Massachusetts, 1943)
The Ghent Portfolio: William Tell, Hay Chair, American Pump,
Siding, Farm Animals, 1990; Pace/MacGill Gallery, New York
Ektacolor prints, 11 x 14 (27.9 x 35.6) each
Edition of 21
Gift of Peter Norton

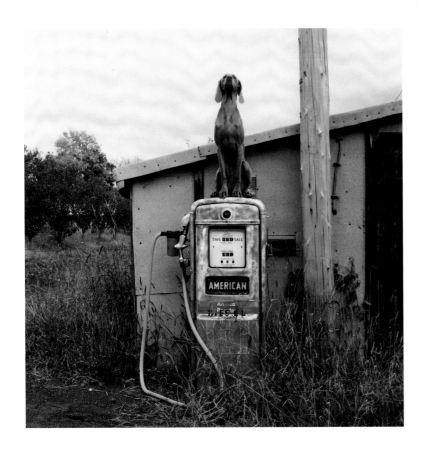

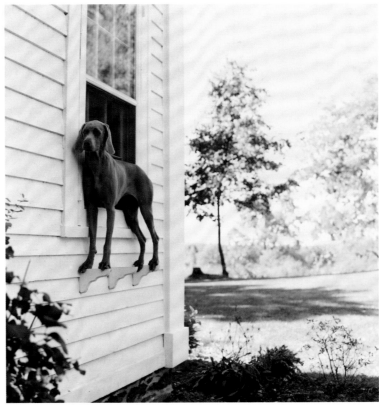

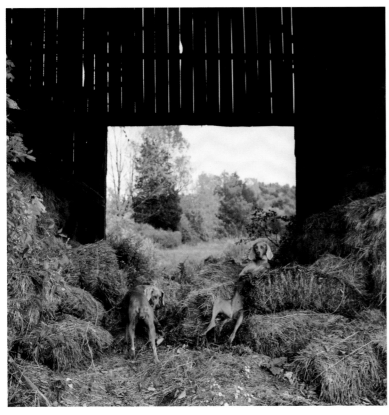

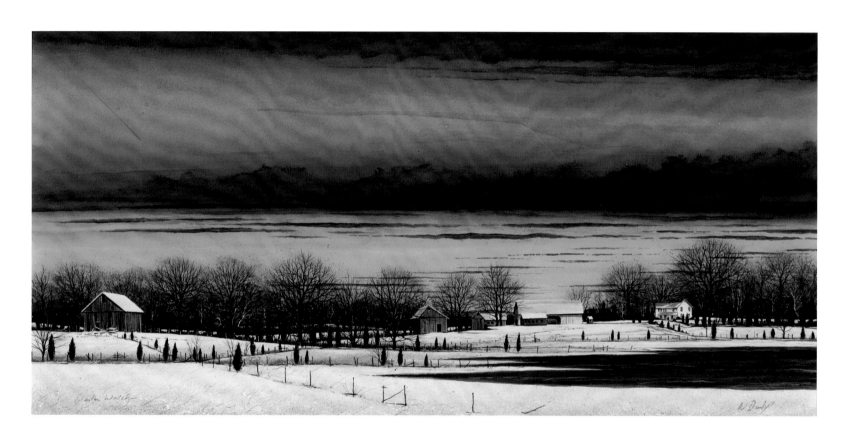

WILLIAM DUNLAP

(Houston, Mississippi, 1944)
Winter Watch, 1999
Oil, watercolor, and dry pigment on paper, 25 x 52 (63.5 x 132.1)
Donated by the artist

JOAN NELSON

(Torrance, California, 1958)
Untitled #2 from *Why Draw a Landscape?*, 1999; Crown Point Press, San Francisco
Gravure, drypoint, and aquatint, 5¾ x 6¼ (14.6 x 15.9)
Edition of 50
Purchased with funds donated by The Brown Foundation, Inc., Houston

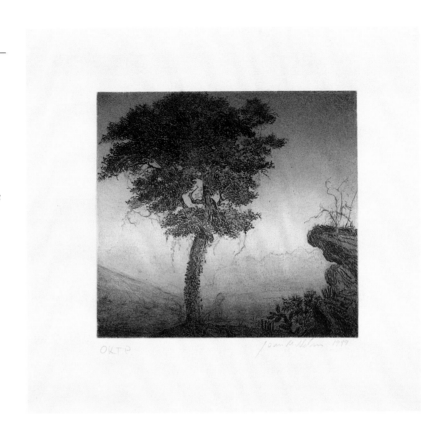

ROBERT BECHTLE

(San Francisco, 1932)
House Near Stinson Beach from *Why Draw a Landscape?*, 1999; Crown Point Press, San Francisco
Etching and aquatint, 8 x 13 (20.3 x 33)
Edition of 50
Purchased with funds donated by The Brown Foundation, Inc., Houston

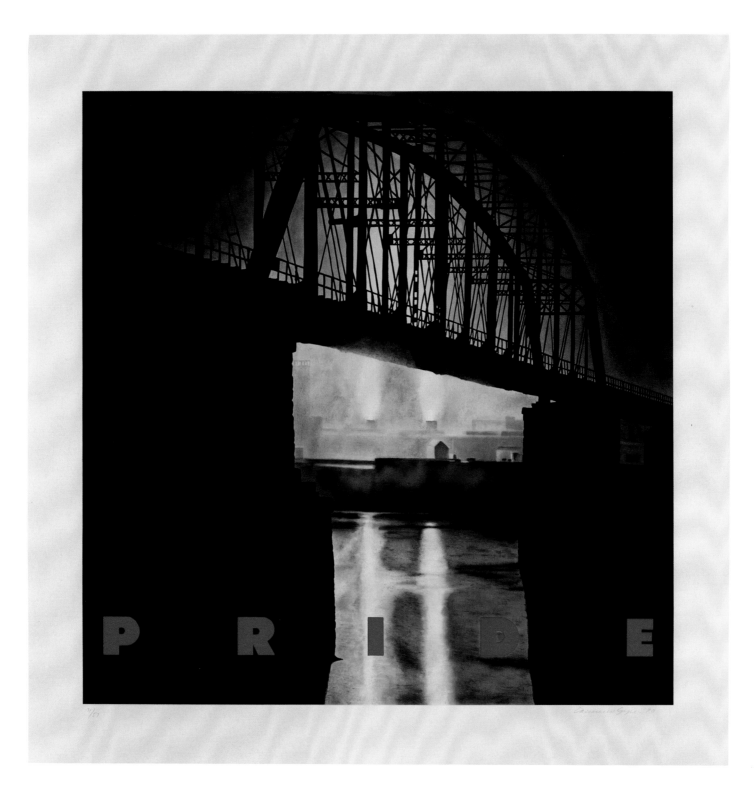

LAWRENCE GIPE

(Baltimore, Maryland, 1962)
Pride, 1990; Carl Bornstein, Santa Monica
Lithograph, 21 x 21 (53.3 x 53.3)
Edition of 57
Donated by Eileen and Peter Norton

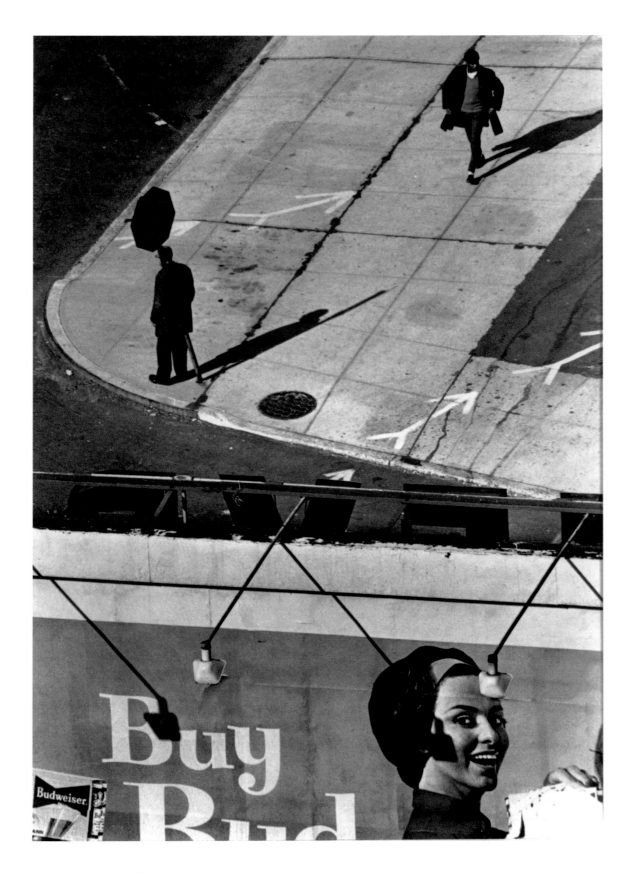

ANDRÉ KERTÉSZ

(Budapest, Hungary, 1894–1985)
New York, 1962
Gelatin silver print, 26 x 20 (66 x 50.8)
Donated by Harriette and Noel Levine

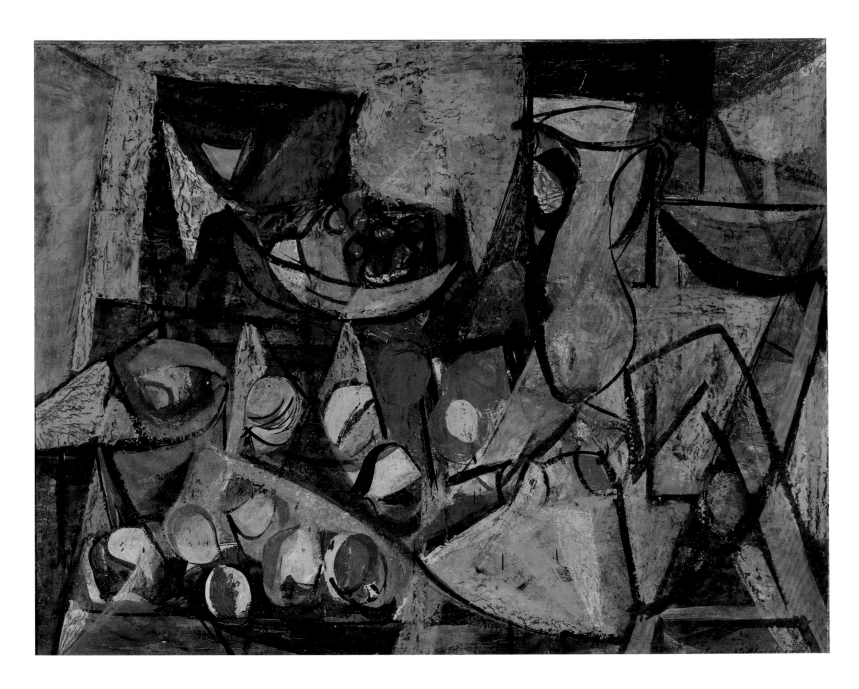

VACLAV VYTLACIL

(New York, 1893–1984)
Still Life Composition with Bowl, 1947
Casein and tempera on board, 35 x 46 (88.9 x 116.8)
Donated by the Estate of Vaclav Vytlacil

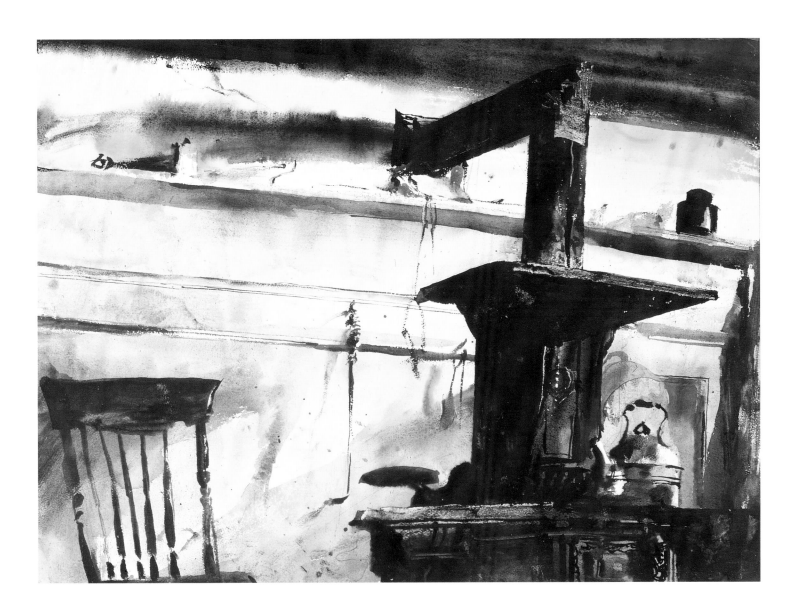

ANDREW WYETH

(Chadds Ford, Pennsylvania, 1917)
Iron Age, 1950
Watercolor, 21 x 29 (53.3 x 73.7)
Donated by MBNA America, Wilmington, Delaware

PROVENANCE

William MacBeth Gallery, New York; Private collection, Greenville, Delaware;
Private collection, New York and Rancho Mirage, California; Spanierman Gallery,
LLC, New York

WILLIAM BAILEY

(Council Bluffs, Iowa, 1930)
Still Life, 1978; Steven Kossak, New York
Lithograph, 18 x 22¼ (45.7 x 56.5)
Edition of 50; printed by Solo Press, New York
Donated by Mrs. William A. Nitze in honor of John C. Whitehead

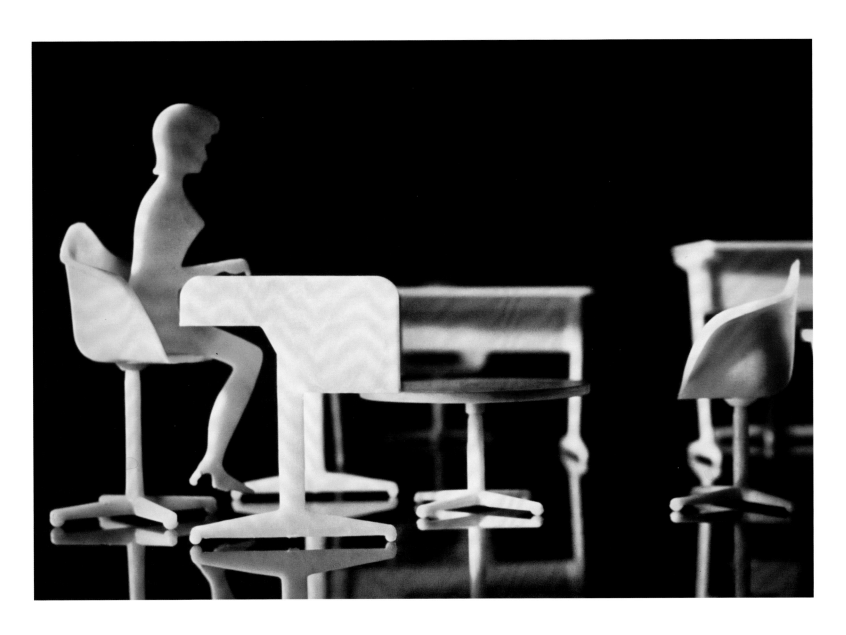

LAURIE SIMMONS

(Far Rockaway, New York, 1949)
Modern Office (with worker), 1998
Ilfochrome, 26⅞ x 39⅝ (68.3 x 100.6)
Donated by B.Z. and Michael Schwartz

JACOB LAWRENCE

(Atlantic City, New Jersey, 1917–2000)
Supermarket—Checkout Counter, 1994
Gouache, 20 x 29¾ (50.8 x 75.6)
Purchased with funds donated by Lee K. McGrath and Dorn C.
McGrath, Jr., in memory of Emanuel Baskin, and with donated funds

PROVENANCE
Collection of the artist; Francine Seders Gallery Ltd., Seattle

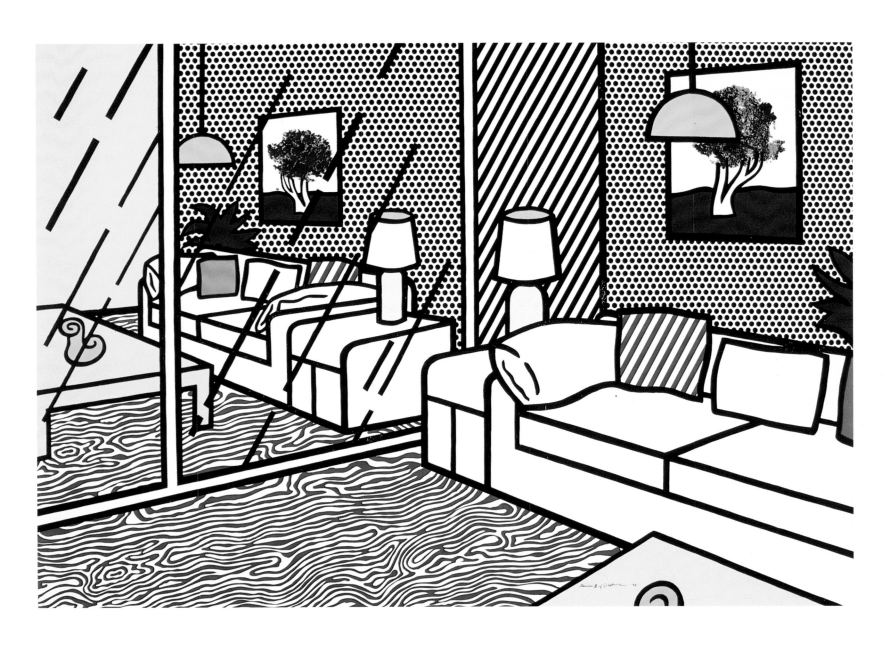

ROY LICHTENSTEIN

(New York, 1923–1997)
Wallpaper with Blue Floor Interior, 1992; Gemini G.E.L., Los Angeles
Screenprint on five sheets, 102 x 152½ (259.1 x 387.4)
Edition of 300; printed by La Paloma, Los Angeles
Donated by Angela K. Westwater

DONALD SULTAN

(Asheville, North Carolina, 1951)
Black Flowers Sept 26 1999, 1999, and *Four Red Flowers May 17 1999*, 1999;
Tyler Graphics Ltd., Mount Kisco, New York
Woodcuts, 28 x 36 (71.1 x 91.4) each
Edition of 40
Donated by Kenneth Tyler, Tyler Graphics Ltd., Mount Kisco, New York

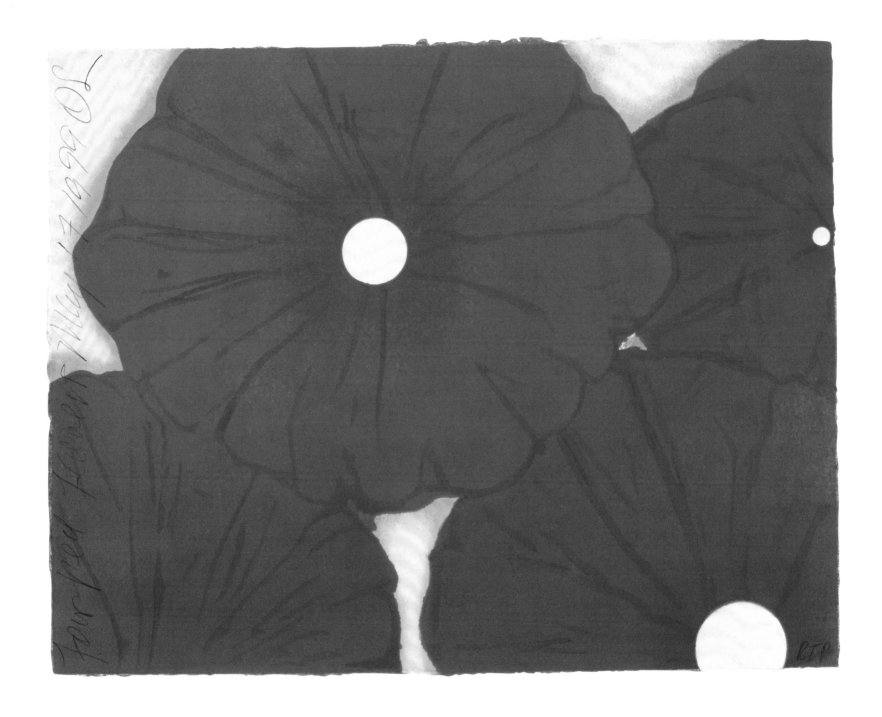

PAT STEIR

(Newark, New Jersey, 1940)
Tiny Green from *Why Draw a Landscape?*, 1999; Crown Point Press,
San Francisco
Aquatint and drypoint, 15⅜ x 11¾ (39.1 x 29.8)
Edition of 50
Purchased with funds donated by The Brown Foundation, Inc.,
Houston

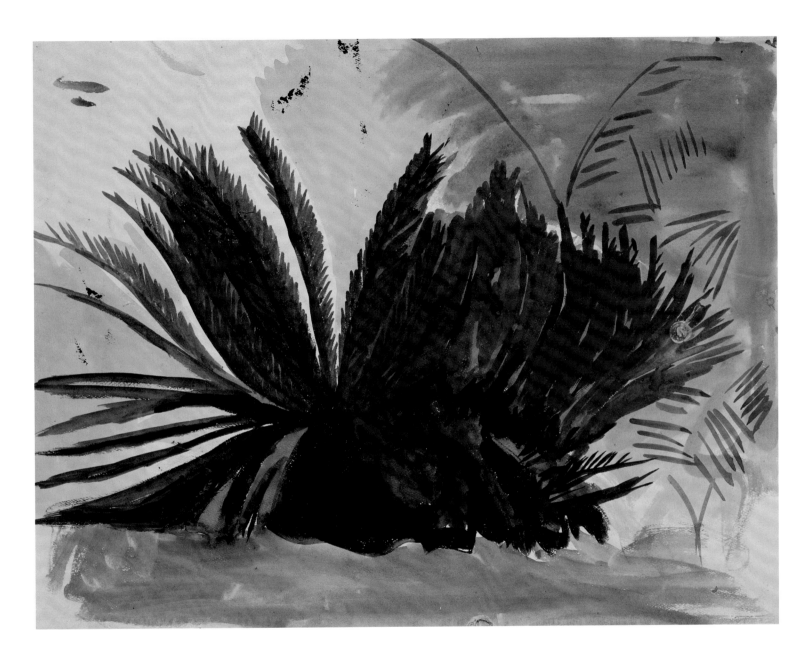

JOSEPH STELLA

(Muro Lucano, Italy, 1877–1946)
Tropical Vegetation (Fern), c. 1938
Watercolor, 18⅝ x 24⅞ (47.3 x 63.2)
Donated by Bernard and Dorothy Rabin

PROVENANCE
Collection of the artist; Rabin & Krueger, New Jersey

TOM MARIONI

(Cincinnati, Ohio, 1937)
Process Landscape from *Why Draw a Landscape?*, 1999; Crown Point Press, San Francisco
Aquatint, 15½ x 10 (39.4 x 25.4)
Edition of 50
Purchased with funds donated by The Brown Foundation, Inc., Houston

ANNE APPLEBY

(Harrisburg, Pennsylvania, 1954)
Winter from *Why Draw a Landscape?*, 1999; Crown Point Press, San Francisco
Aquatint, 8⅜ x 11 (21.3 x 27.9)
Edition of 50
Purchased with funds donated by The Brown Foundation, Inc., Houston

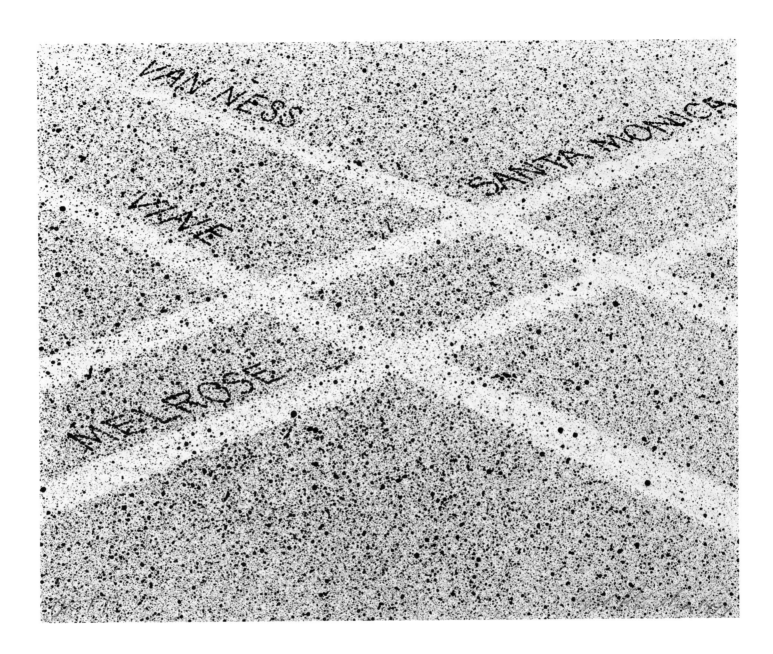

EDWARD RUSCHA

(Omaha, Nebraska, 1937)
Van Ness, Santa Monica, Vine, Melrose from *Why Draw a Landscape?*,
1999; Crown Point Press, San Francisco
Direct gravure, 16 x 20 (40.6 x 50.8)
Edition of 50
Purchased with funds donated by The Brown Foundation, Inc.,
Houston

FRANK STELLA

(Malden, Massachusetts, 1936)
Conway #1, 1966
Acrylic on canvas, 80 x 122½ (203.2 x 311.2)
Donated by Douglas S. Cramer

PROVENANCE
Jules Olitski

Sunset Beach Sketch, 1967
Fluorescent and plain alkyd on canvas, 69 x 69 (175.3 x 175.3)
Donated by Sara Lee Corporation, Chicago

ROBERT RAUSCHENBERG

(Port Arthur, Texas, 1925)
Dog Tags, 1996
Vegetable dye transfer, 60½ x 94¾ (153.7 x 240.7)
Donated by The Honorable and Mrs. Ronald S. Lauder

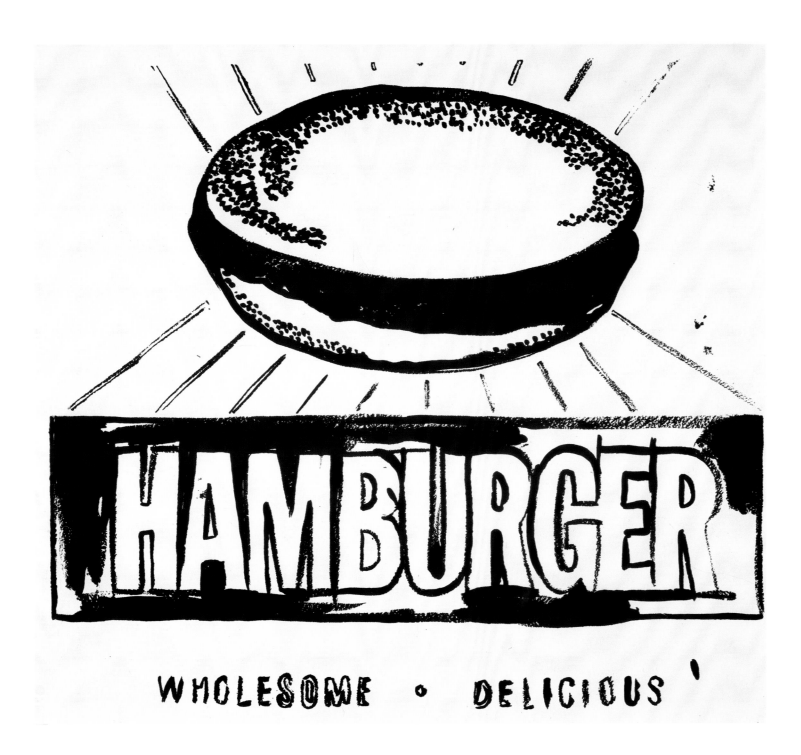

ANDY WARHOL

(McKeesport, Pennsylvania, 1928–1987)
Hamburger, 1985–86
Synthetic polymer paint and silkscreen ink on canvas, 72 x 80
(182.9 x 203.2)
Donated by The Andy Warhol Foundation for the Visual Arts, Inc.

PROVENANCE
Estate of the artist

LENORE TAWNEY

(Lorain, Ohio, 1907)
Untitled, 1974
Linen, denim, and buttons, 46 x 50 (116.8 x 127)
Donated by the artist and The Honorable and Mrs. Edward E. Elson

Our Craft Traditions

Native Americans were and are deeply and spiritually involved in making useful objects by hand. Their basket and yarn weaving is a fundamental tradition in a country where other nationalities have brought similar traditions with them. The revival of such crafts has occurred several times since the Industrial Revolution. Many craft artists of both native and foreign backgrounds still work in rural areas of the South, Southwest, and Northwest. Their objects often embody responses to the functional and esthetic needs of their own communities. Nonetheless, works that may have originally derived from spiritual inspiration have developed within the broader context of American life.

Late twentieth-century work has encompassed an extraordinary amalgamation of ceramic, glass, woodworking, and weaving techniques with some elements of fine art imagery and composition. A basic desire to transform the ordinary into something wonderful to touch is fulfilled by the ways in which artists manipulate such diverse materials as twigs, native clay, hemp, and molten glass. In America, this has meant an infinite infusion of custom and invention.

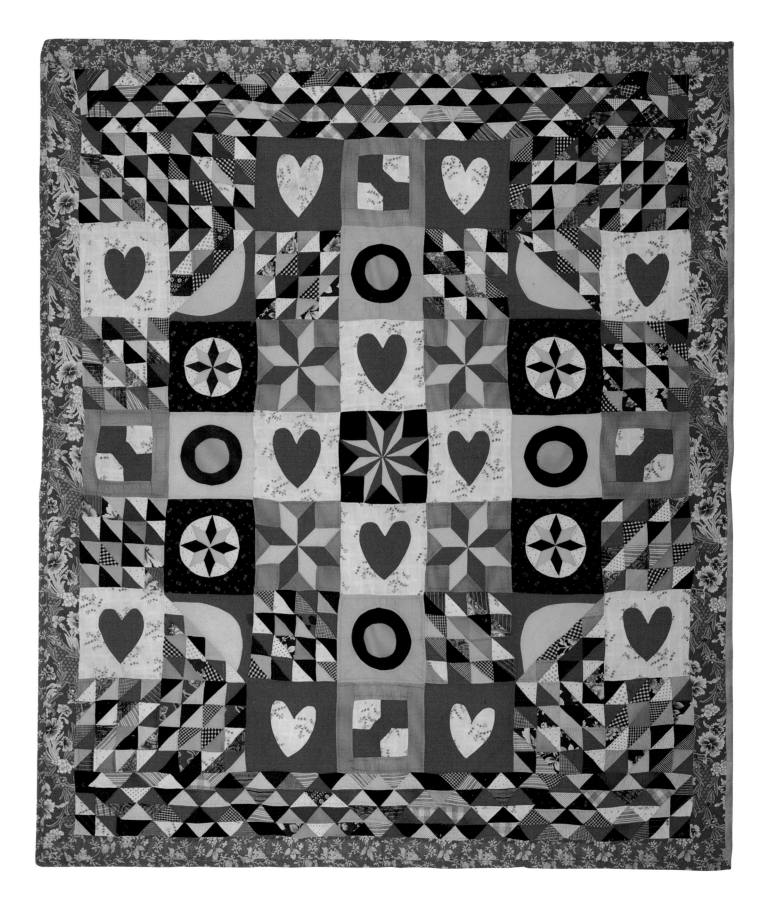

Anonymous

Hearts and Stars quilt, c. 1920–30
Cotton, 80 x 69½ (203.2 x 175.3)
Donated by Stephen Score, Inc., Boston

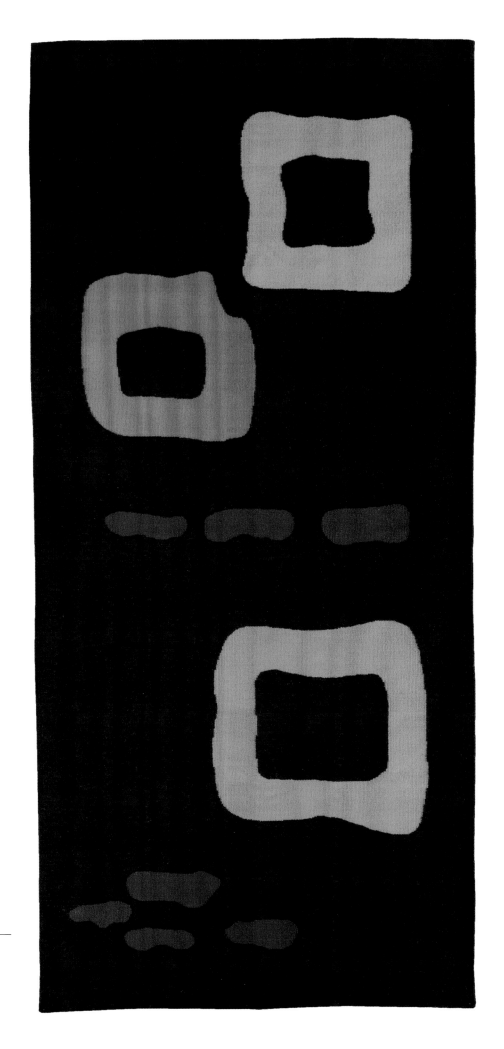

RAMONA SAKIESTEWA

(Albuquerque, New Mexico, 1948)
Yellow Spotted Corn, 1995
Wool, 87 x 40 (221 x 101.6)
Purchased with donated funds

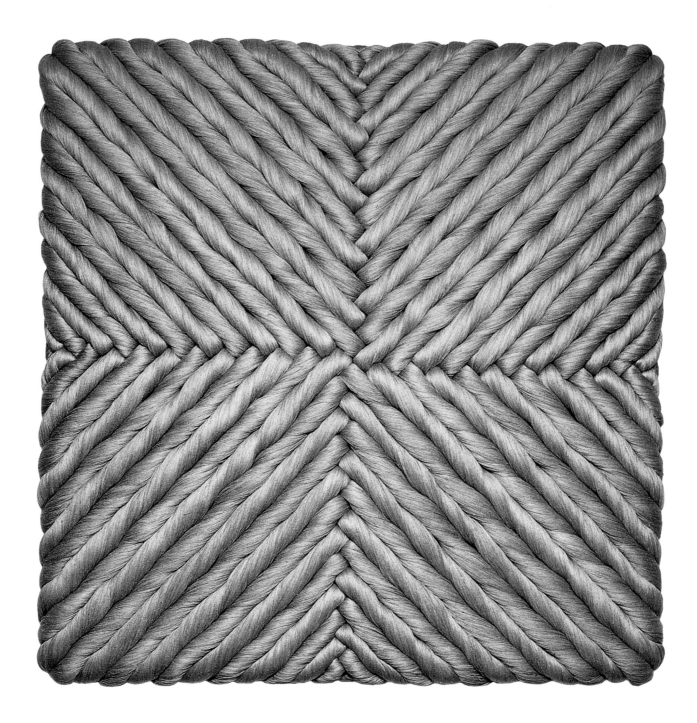

SHEILA HICKS

(Hastings, Nebraska, 1934)
Foley Square, 1997
Linen, 38 x 38 (96.5 x 96.5)
Donated by the artist and browngrotta arts, Wilton, Connecticut

TOSHIKO TAKAEZU

(Pkeekeo, Hawaii, 1922)
Magic Circle, 1973
Wool, linen, silk, rayon, and cotton,
88 x 51 x 1½ (223.5 x 129.5 x 3.8)
Donated by the artist

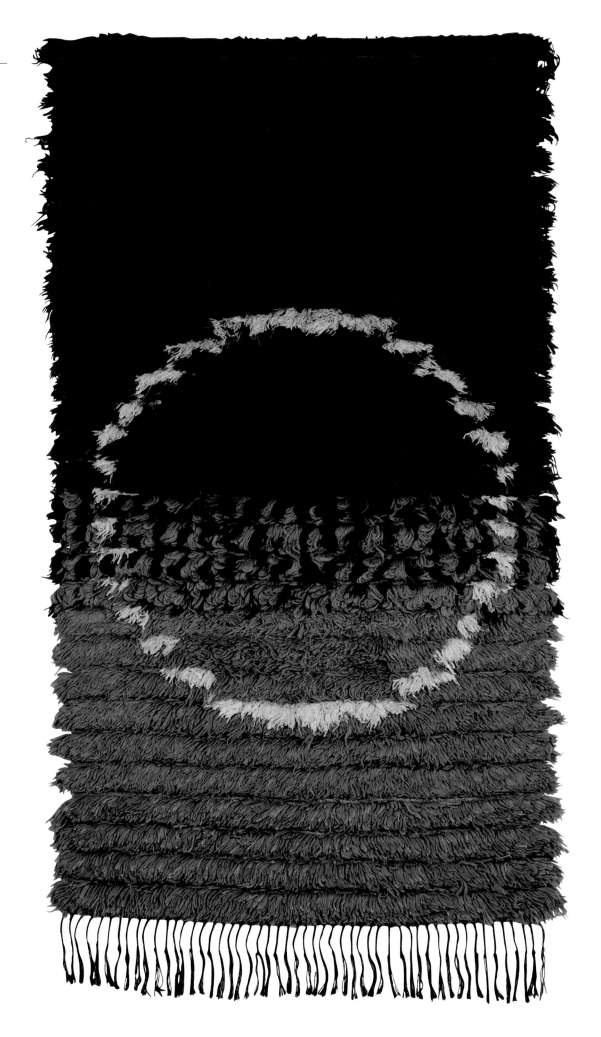

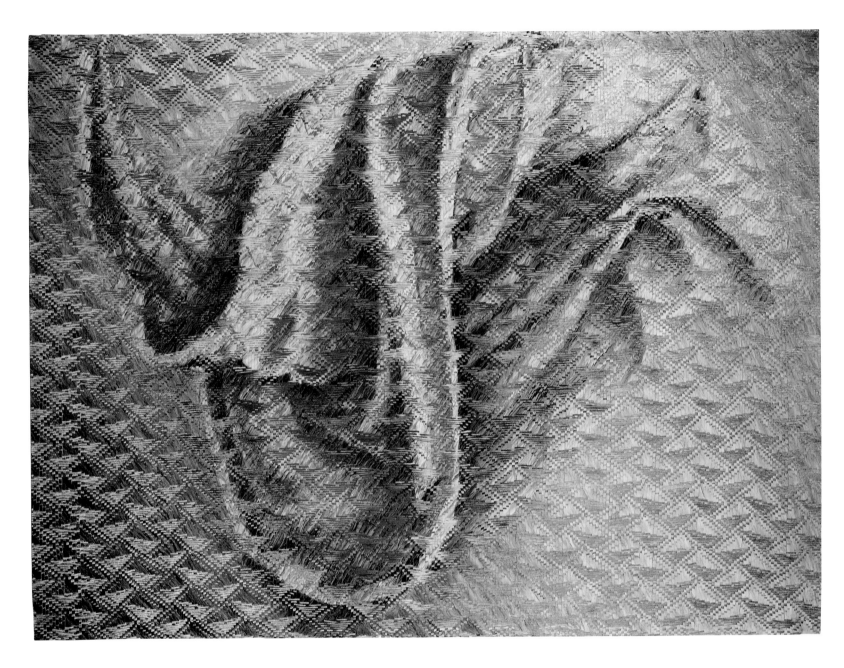

LIA COOK

(Ventura, California, 1942)
New Master Draperies: Michelangelo, 1991
Dyes and acrylic on rayon and linen, 50 x 67 (127 x 170.2)
Donated by the artist and purchased with donated funds

(Winter Haven, Florida, 1953)
Maple/Red Circles, 2000
Chair, glass, paint, and mixed media,
45½ x 17 x 18½ (115.6 x 43.2 x 47)
Purchased with donated funds

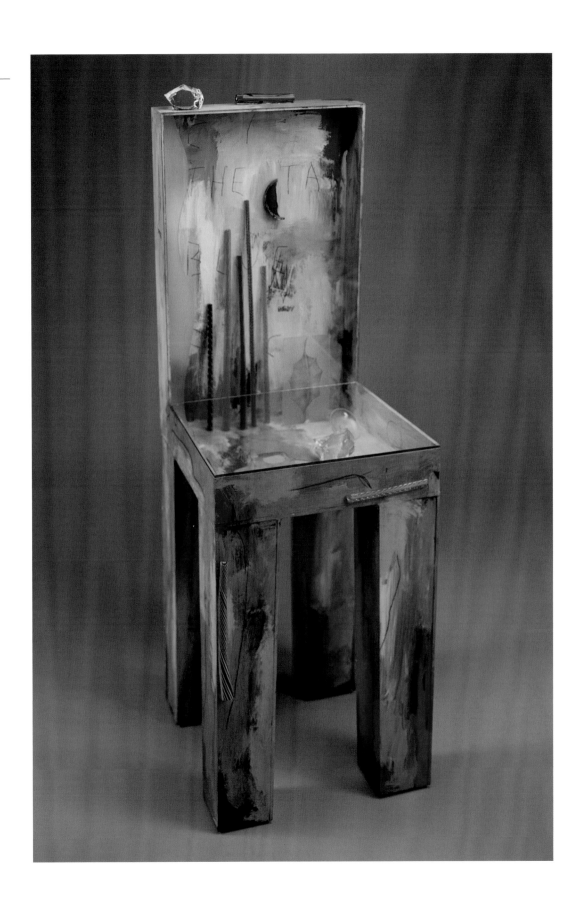

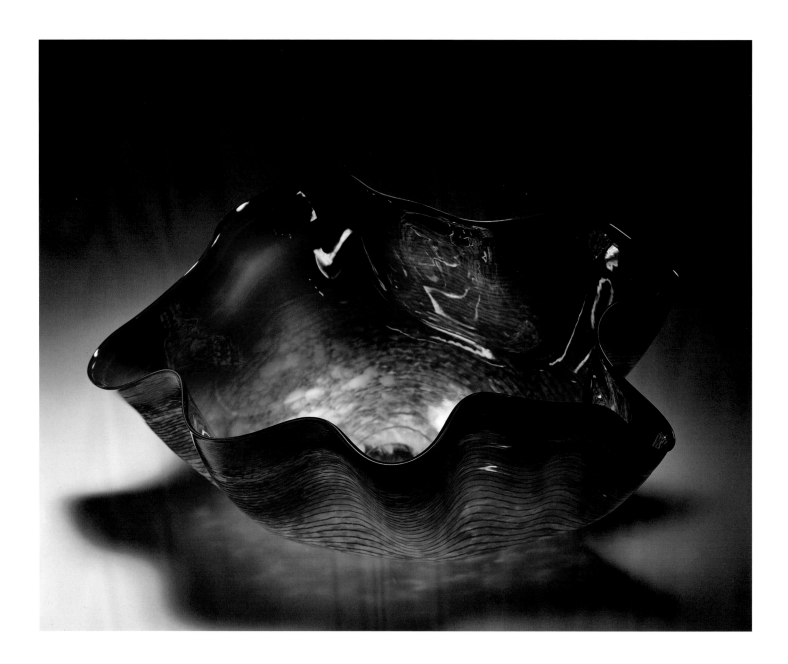

DALE CHIHULY

(Tacoma, Washington, 1941)
Oxblood Macchia with Teal Lip Wrap, 1984
Hand-blown glass, 12 x 27½ x 22⅞ (30.5 x 69.9 x 58.1)
Donated by Becky and Jack Benaroya

PROVENANCE
Collection of the artist

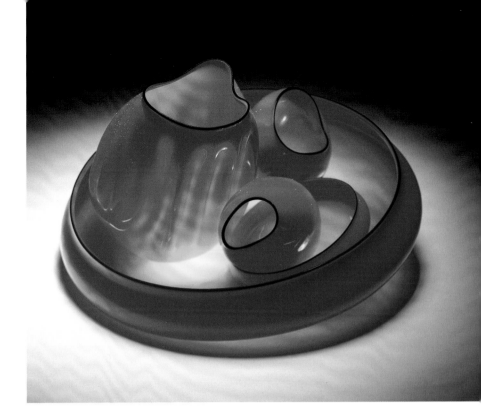

Crimson Basket Set, 1990s
Hand-blown glass, five elements, 8 x 15 diameter (20.3 x 38.1)
Donated anonymously

PROVENANCE
Collection of the artist

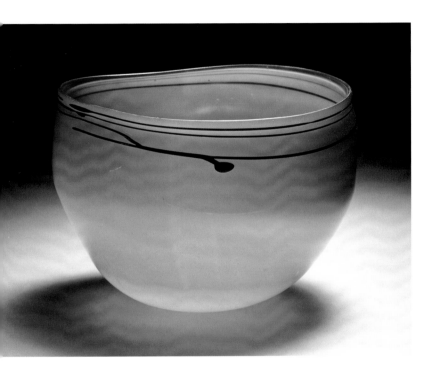

Tabac Basket, 1980s
Hand-blown glass, 10½ x 7½ diameter (26.7 x 19.1)
Donated by Virginia and Bagley Wright

PROVENANCE
Collection of the artist

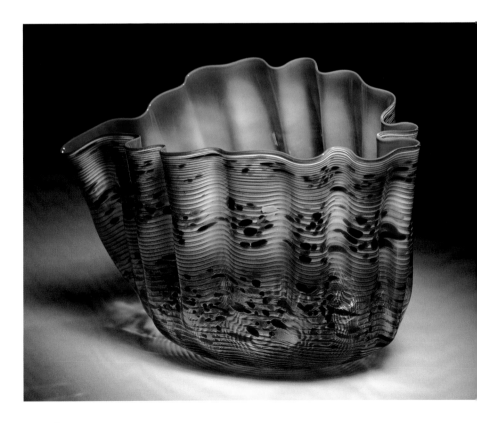

Macchia, 1986–92
Hand-blown glass, 16 x 10 x 11½ (40.6 x 25.4 x 29.2)
Donated by John H. Hauberg

PROVENANCE
Collection of the artist

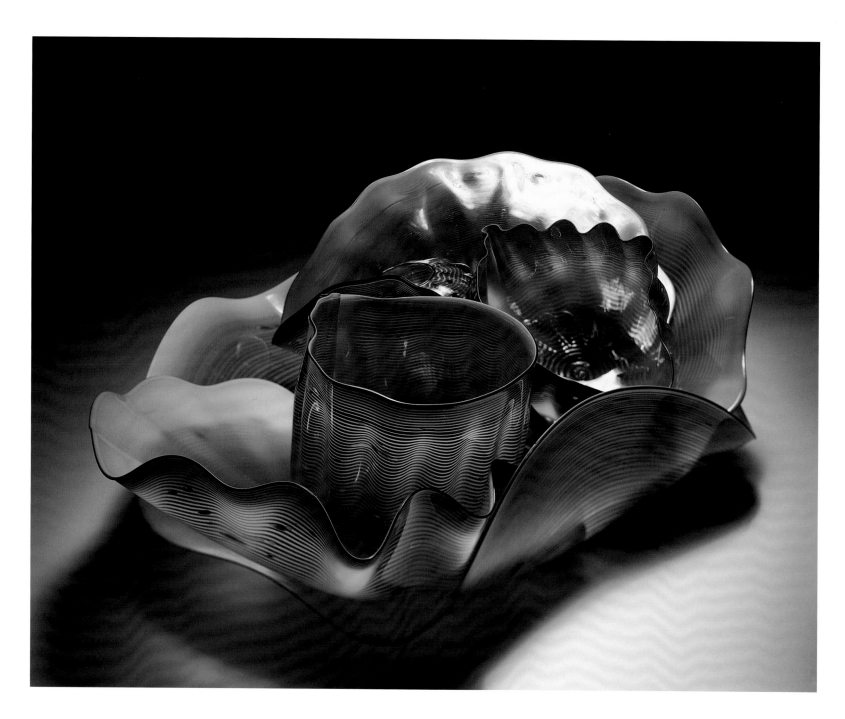

DALE CHIHULY

(Tacoma, Washington, 1941)
Gray Seaform Set, 1984
Hand-blown glass, seven elements, 24½ x 31½ x 9¾ (62.2 x 80 x 24.8)
Donated by Mr. and Mrs. Jeffrey Brotman

PROVENANCE
Collection of the artist

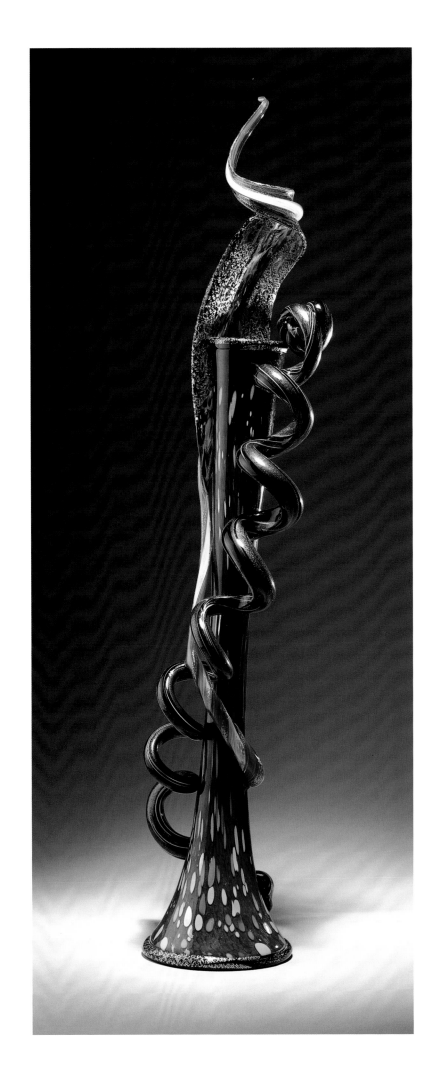

English Red Venetian with Black Coil, 1990
Hand-blown glass, 45 x 10 x 10 (114.3 x 25.4 x 25.4)
Donated by Mr. and Mrs. Jon Shirley

PROVENANCE

John Berggruen Gallery, San Francisco

PHILIP MOULTHROP

(Atlanta, 1947)
Bull's Eye, 1989
Streaked Georgia pine, 11½ x 12 (29.2 x 30.5)
Donated by Jane and Arthur Mason

ED MOULTHROP

(Rochester, New York, 1916)
Morning Glory, 1995
Ash-leaf maple, 11¼ x 16 (28.6 x 40.6)
Donated by Jane and Arthur Mason

MARY A. JACKSON

(Mount Pleasant, South Carolina, 1945)
Sweetgrass baskets
Purchased with funds donated by The
David and Lucile Packard Foundation

*Traditional Grain Storage Basket I (with
tall handle)*, 2000
Sweetgrass, bulrush, pine needles, and
palmetto, 17 x 5½ x 11 (43.2 x 14 x 27.9)

Oval Vessel with Sweetgrass Spray, 2000
Sweetgrass, bulrush, pine needles, and
palmetto, 6 x 18 x 14 (15.2 x 45.7 x 35.6)

Cobra with Handle, 2000
Sweetgrass, bulrush, pine needles, and
palmetto, 14 x 16½ x 14 (35.6 x 40.6 x 35.6)

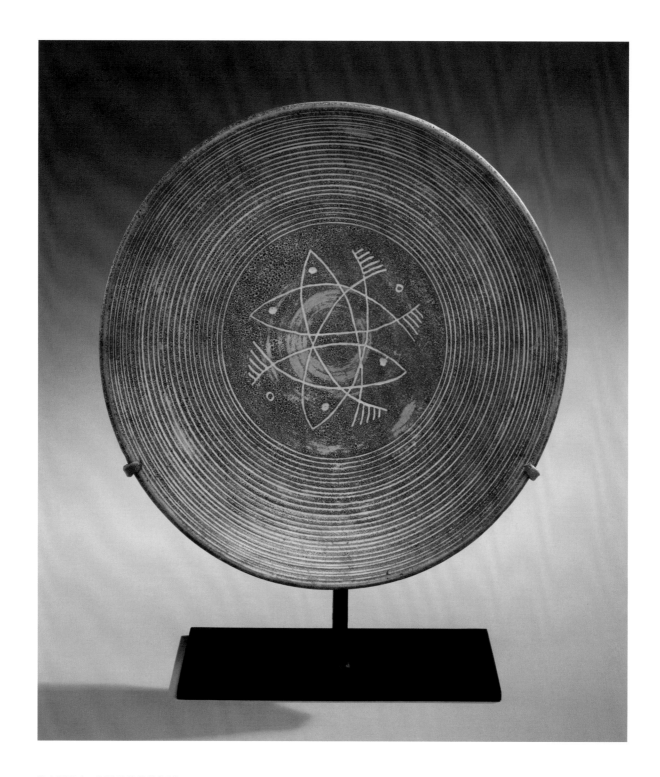

LAURA ANDRESON

(San Bernadino, California, 1902–2000)
Charger, 1945
Glazed earthenware, 13⅝ (34.6) diameter
Donated by Daniel Morris, Historical Design, Inc., New York

PROVENANCE
Private collection, San Francisco

PETER VOULKOS

(Bozeman, Montana, 1924)
Untitled, 1973
Stoneware with porcelain and glaze, 19½ (49.5) diameter
Purchased with funds donated by Nanette L. Laitman

PROVENANCE
Exhibit A, Chicago; Private collection, Chicago

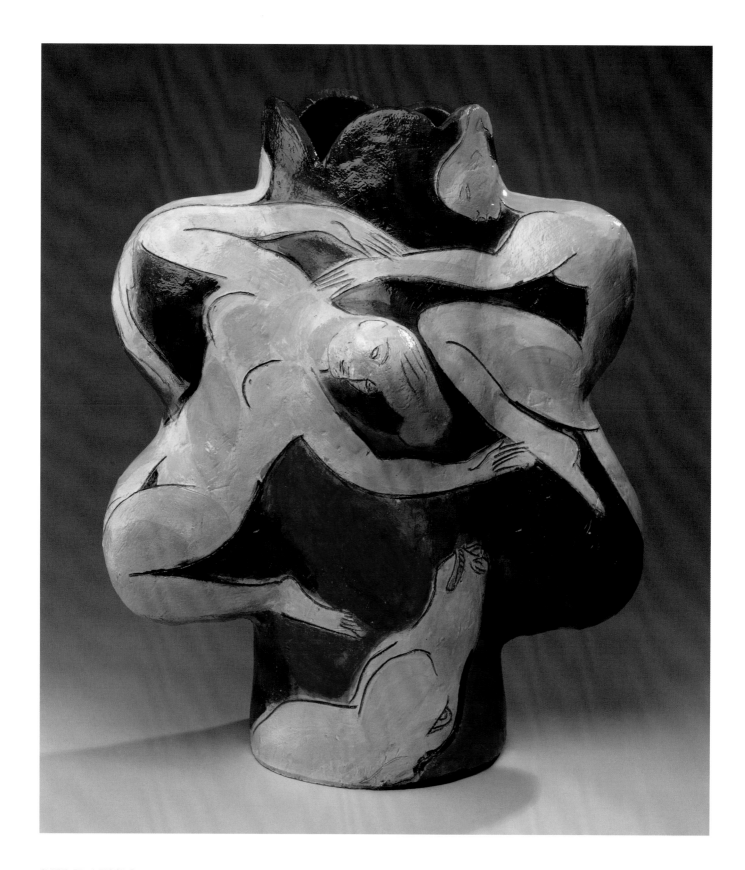

RUDY AUTIO

(Butte, Montana, 1926)
Revue, 1997
Stoneware, 33½ x 29 x 21 (85.1 x 73.7 x 53.3)
Donated by the E.R. Roberts Family Foundation

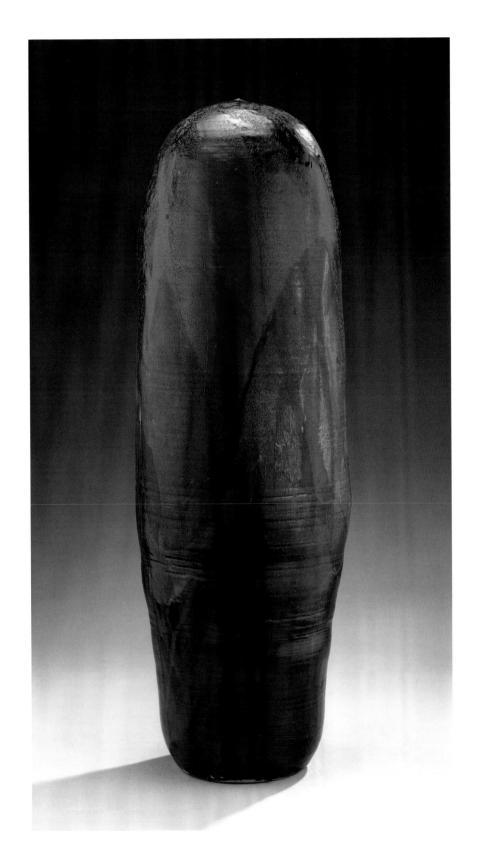

TOSHIKO TAKAEZU

(Pkeekeo, Hawaii, 1922)
Makaha Blue, 1995
Porcelain, 30 x 10 diameter (76.2 x 25.4)
Donated by the artist

BETTY WOODMAN

(Norwalk, Connecticut, 1930)
Summer Solstice, 2001
Glazed earthenware, epoxy, lacquer, and paint, 72 x 72 x 1 (182.9 x
182.9 x 2.5)
Donated by the artist and Max Protetch Gallery, New York

Balustrade Relief Vase, 1999
Glazed earthenware, epoxy, lacquer, and paint, 64 x 56¾ x 9
(162.6 x 144.1 x 22.9)
Purchased with funds donated by Sheila Johnson Robbins

LARRY FLOAT, SR.

(Mekoryuk, Alaska, 1935–2001)
Yup'ik (Walrus/Whale Spirit) Mask, c. 1999
Wood and pigment, 28 x 24½ x 4½ (71.1 x 62.2 x 11.4)
Donated by National Bank of Alaska/Wells Fargo, Anchorage

LOLA E.A. FERGUSON

(Mekoryuk, Alaska, 1963)
Cu'piq (Double Walrus Spirit) Mask, c. 1999
Wood, pigment, red clay, seal blood, India ink with coal, and reindeer
sinew, 33½ x 34 x 6 (85.1 x 86.4 x 15.2)
Donated by National Bank of Alaska/Wells Fargo, Anchorage

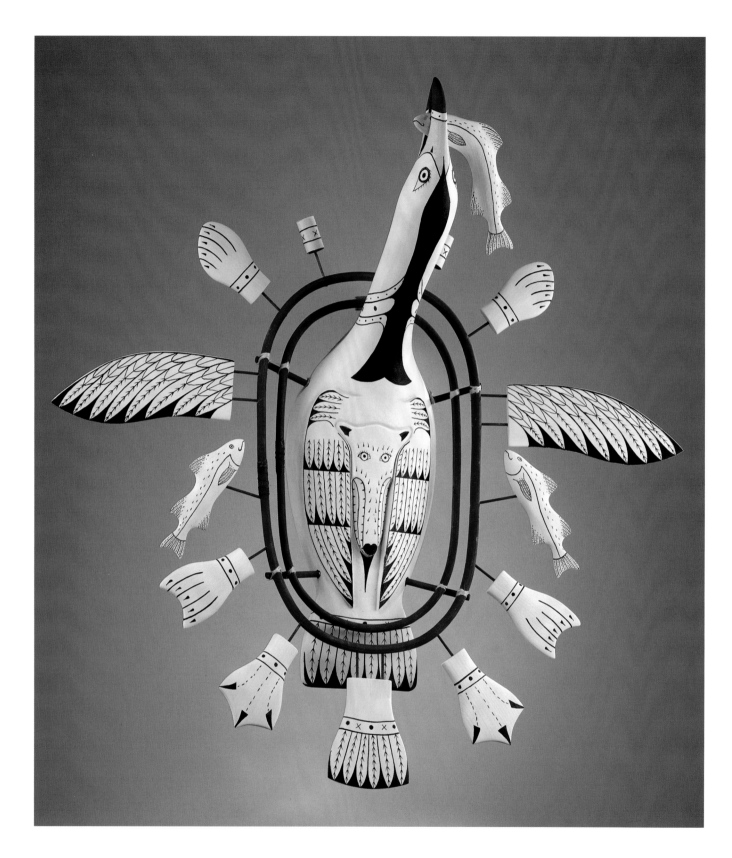

WALTER T. AMOS

(Mekoryuk, Alaska, 1920)
Cup'ik (Ancient Nunivak Loon) Mask, c. 1999
Wood and pigment, 30 x 30¾ x 13 (76.2 x 78.1 x 33)
Donated by National Bank of Alaska/Wells Fargo, Anchorage

Our Imagination

When artists began to eliminate realistic subjects from their compositions—freeing line, color, and form from the restrictions of representation—abstraction and the new concepts that followed broadened the possibilities of art. Simultaneously, a continuing tendency to evoke aspects of reality was divided between surrealism and expressionism. In all cases, the imagination of the artist required the imaginative collaboration of the viewer, the suspension of thinking and seeing in traditional ways, and an appreciation of both the material and the manner of execution in an artwork.

Some of the artists whose work is included here developed their styles in Europe and later taught in American schools. The GI Bill enabled Americans who served in World War II to study art in the United States and abroad. Many became artists and teachers of art, developing the context for a rapidly expanding audience for the fine arts. America, a country of enormous size and diversity, has produced an equally expansive and multi-faceted cultural treasure through the breadth of invention, variety of viewpoints, and bravery of imagination of its creative citizens.

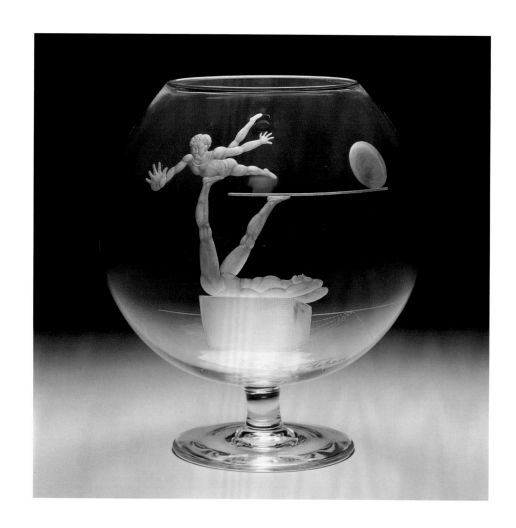

PAVEL TCHELICHEW

(Moscow, Russia, 1898–1957)
Vase from *Twenty-Seven Contemporary Artists*, 1939; Steuben Glass,
Inc., New York
Acid-etched glass, 13½ x 12 diameter (34.3 x 30.5)
Edition of six
Donated by Anthony DeLorenzo

PROVENANCE
Sotheby's, New York

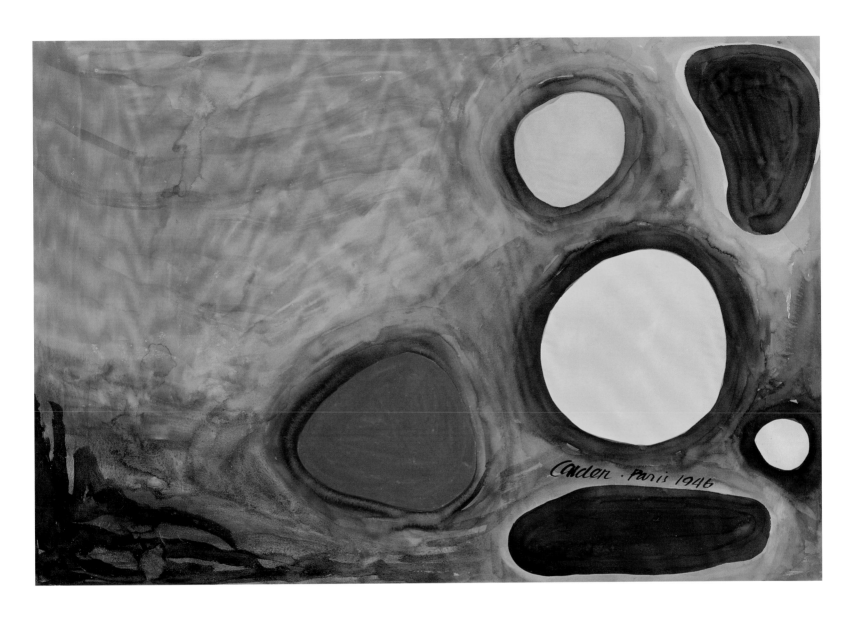

ALEXANDER CALDER

(Philadelphia, 1898–1976)
Shapes in Space, 1946
Gouache, 46½ x 33 (118.1 x 83.8)
Donated by David and Gerry Pincus

JOHN VON WICHT

(Malente, Germany, 1888–1970)
Untitled #68, c. 1954
Oil on paper, 38 x 25 (96.5 x 63.5)
Donated by James J. Coyle, Jr.

PROVENANCE
Collection of the artist

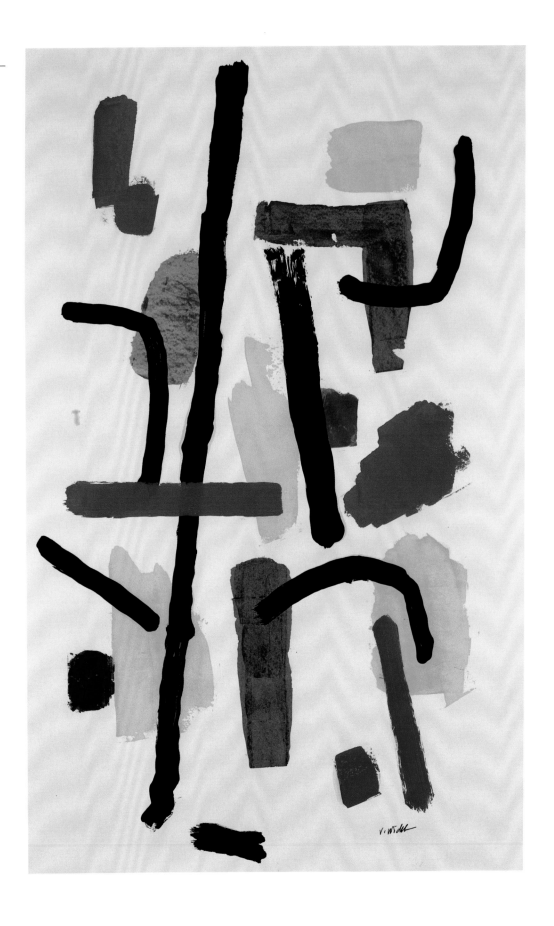

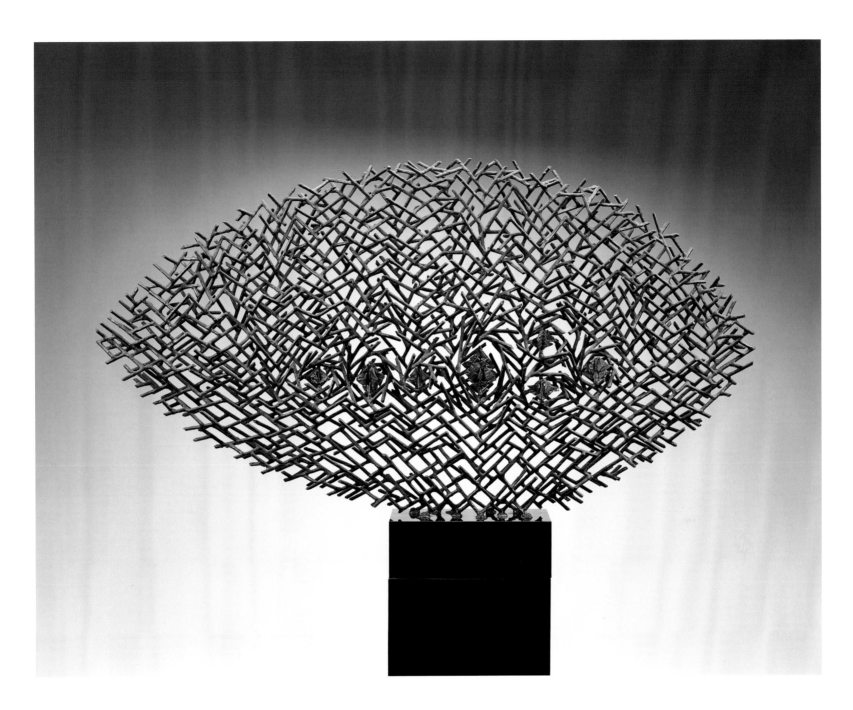

RICHARD FILIPOWSKI

(n.p., Poland, 1923)
Mozart, 1963
Bronze and silver, 25½ x 49 x 5 (64.8 x 124.5 x 12.7)
Donated by David Rockefeller

PROVENANCE
Joan Peterson Gallery, Boston

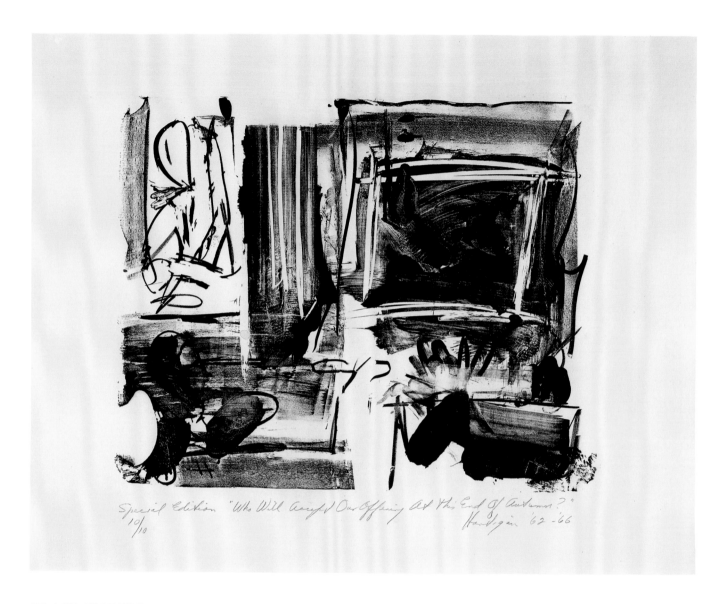

GRACE HARTIGAN

(Newark, New Jersey, 1922)
The Archaics: Who Will Accept Our Offering at This End of Autumn?,
1962–66; Universal Limited Art Editions, West Islip, New York
Lithograph, 13¾ x 17¼ (34.9 x 43.8)
Special edition of ten
Donated by Mr. and Mrs. Edgar B. Howard

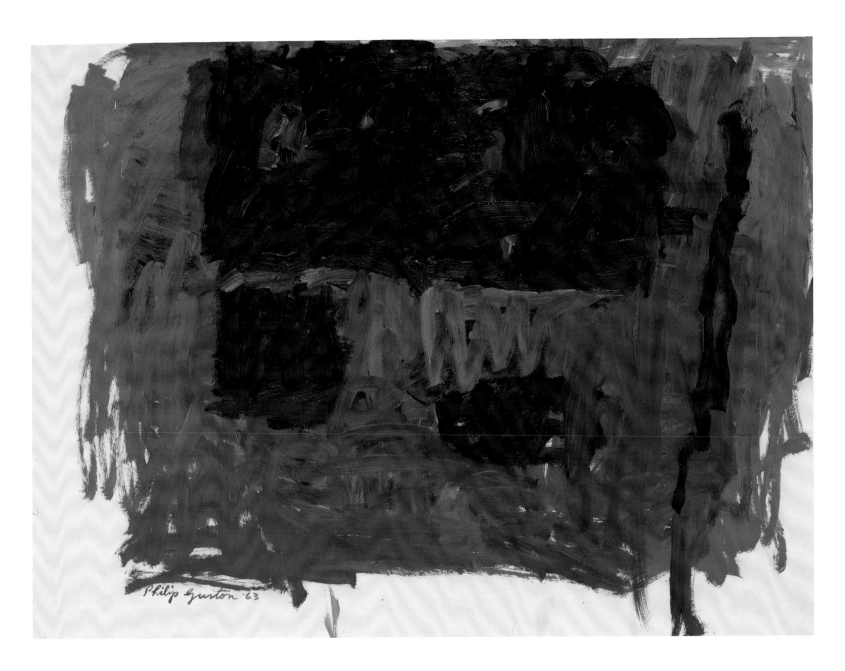

PHILIP GUSTON

(Montreal, 1913–1980)
The Day, 1963
Oil on paper, 30¼ x 40½ (76.8 x 102.9)
Donated by Musa and Tom Mayer

PROVENANCE
Collection of the artist

MARK TOBEY

(Centreville, Wisconsin, 1890–1976)
Untitled, 1965
Monotype, 39¼ x 19¾ (99.7 x 50.2)
Donated by Achim Moeller Fine Art,
New York

PROVENANCE

Hanover Gallery, London; Roger Collection,
Scotland

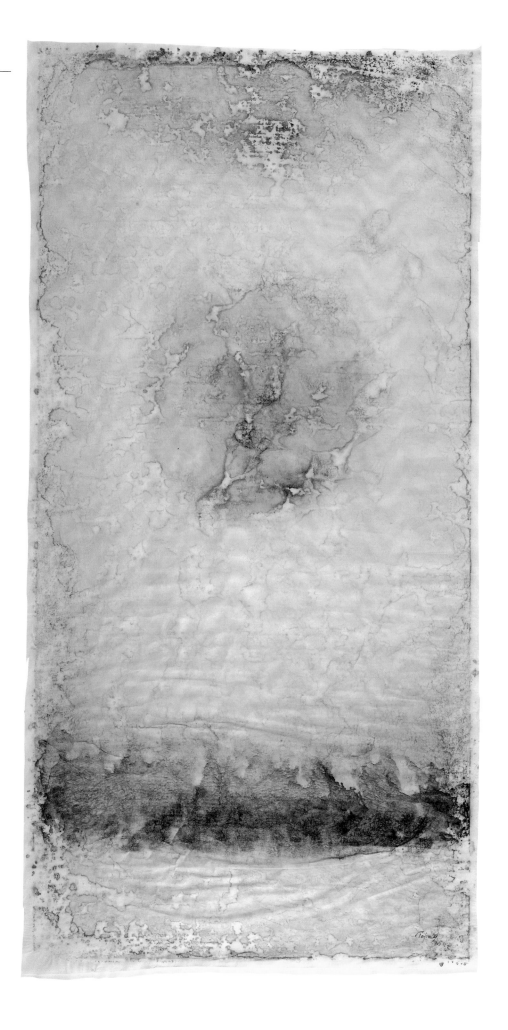

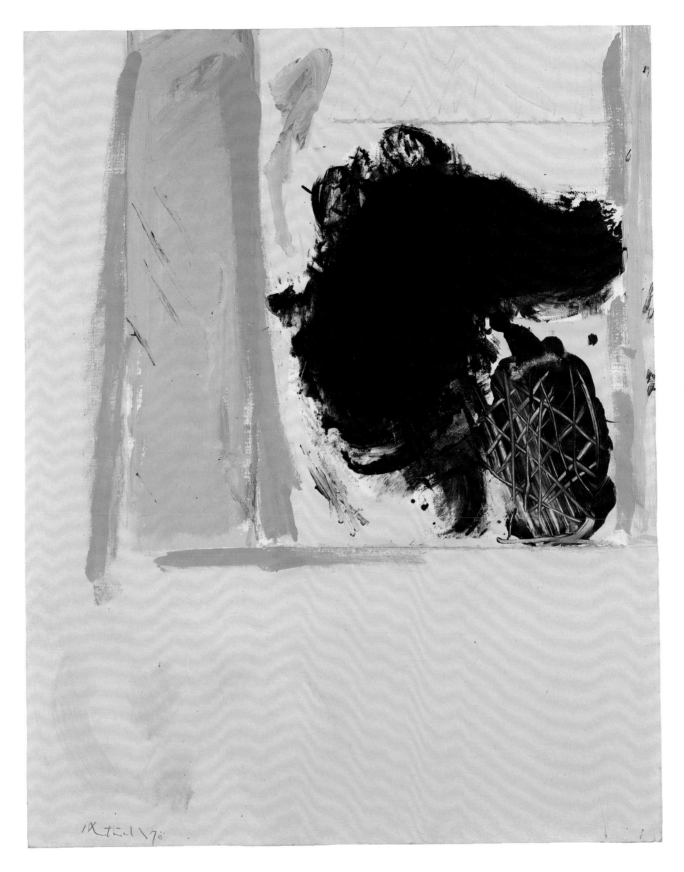

ROBERT MOTHERWELL

(Aberdeen, Washington, 1915–1991)
Window with Black Cloud, 1970
Acrylic on canvasboard, 30 x 24 (76.2 x 61)
Donated by the Dedalus Foundation, Inc.

PROVENANCE
Collection of the artist

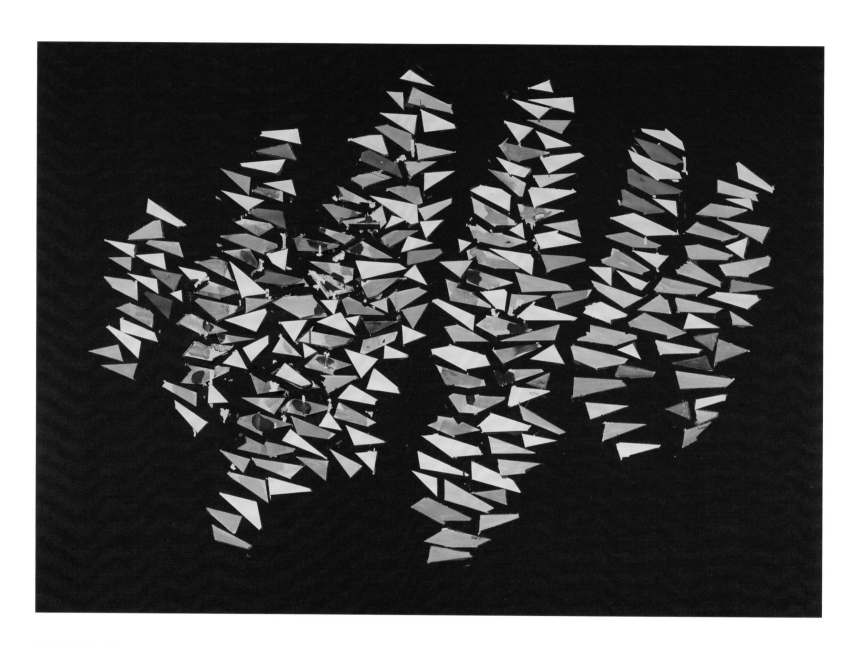

ROBERT GOODNOUGH

(Cortland, New York, n.d.)
Quiet Clusters, 1998
Oil and acrylic on canvas, 40 x 56 (101.6 x 142.2)
Donated by the artist

HELEN FRANKENTHALER

(New York, 1928)
A Page From A Book I, 1997; Tyler Graphics Ltd., Mount Kisco, New York
Etching, aquatint, mezzotint, and stencil, 10⅛ x 24¾ (25.7 x 62.9)
Edition of 60
Donated by Kenneth Tyler, Tyler Graphics Ltd., Mount Kisco, New York

A Page From A Book II, 1997; Tyler Graphics Ltd., Mount Kisco, New York
Etching and aquatint, 10⅛ x 24¾ (25.7 x 62.9)
Edition of 60
Donated by Kenneth Tyler, Tyler Graphics Ltd., Mount Kisco, New York

BURGOYNE DILLER

(New York, 1906–1965)
Untitled, 1948
Pencil, 9 x 8 (22.9 x 20.3)
Donated by Nancy Schwartz

PROVENANCE
Noah Goldowsky Gallery, New York; Vera Neumann

LOUISE NEVELSON

(Kiev, Russia, 1899–1988)
Silent Motion, 1964
Painted wood and mirror, 43½ x 58½ (110.5 x 148.6)
Purchased with funds donated by the Kimsey Foundation

PROVENANCE
Private collection, Massachusetts; PaceWildenstein Gallery, New York

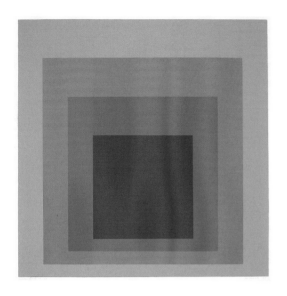
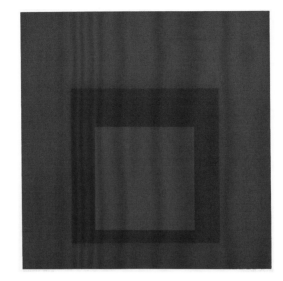

JOSEF ALBERS

(Bottrop, Germany, 1888–1976)
Golden Gate, Palatial, Nacre, Late, Porta Negra
from *Homage to the Square: Soft Edge-Hard
Edge*, 1965; Ives-Sillman, New Haven,
Connecticut
Screenprints, 11 x 11 (27.9 x 27.9) each
Edition of 50
Donated by John D. Herring in memory of
Mr. and Mrs. H. Lawrence Herring

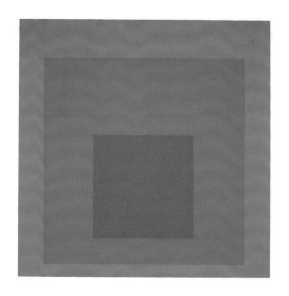

Emeraude, Profundo, Arctic Bloom, Pending,
Arrived from *Homage to the Square:*
Soft Edge-Hard Edge, 1965; Ives-Sillman,
New Haven, Connecticut
Screenprints, 11 x 11 (27.9 x 27.9) each
Edition of 50
Donated by John D. Herring in memory of
Mr. and Mrs. H. Lawrence Herring

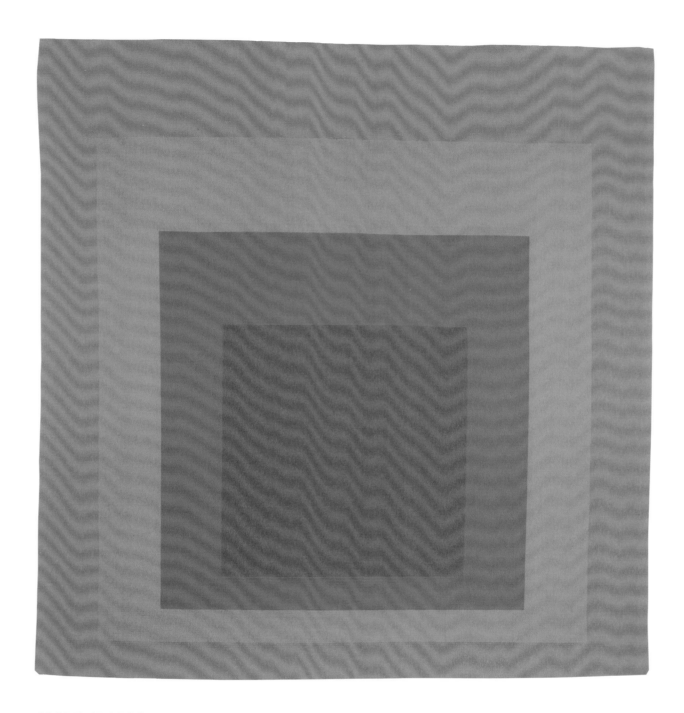

JOSEF ALBERS

(Bottrop, Germany, 1888–1976)
Two Ochres, Yellow, Orange, 1967
Hand-woven wool, 71 x 71 (180.3 x 180.3)
Donated by The Josef and Anni Albers Foundation

PROVENANCE
Estate of the artist

KENNETH NOLAND

(Asheville, North Carolina, 1924)
Treble, 1980
Acrylic on canvas, 92⅝ x 178⅜ (235.3 x 453.1)
Donated by Paige Rense Noland

PROVENANCE
André Emmerich Gallery, New York

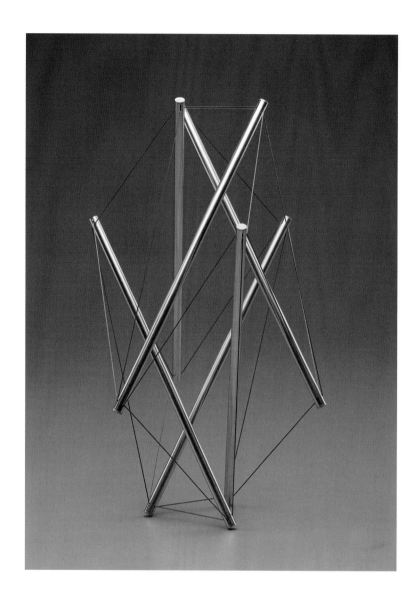

KENNETH SNELSON

(Pendleton, Oregon, 1927)
Untitled (maquette for Woodfield Shopping Center commission,
Schaumberg, Illinois), 1969
Anodized aluminum and stainless steel, 11 x 10 x 10 (27.9 x 25.4 x 25.4)
Donated by A. Alfred Taubman

BEVERLY PEPPER

(Brooklyn, New York, 1924)
Ordine Rettangolo Stretto, 1968
Stainless steel, four elements,
78 x 58 x 22 (198.1 x 147.3 x 55.9)
Donated by Sidley & Austin,
Washington, D.C. Office

PROVENANCE
Collection of the artist; Marlborough
Gallery, New York

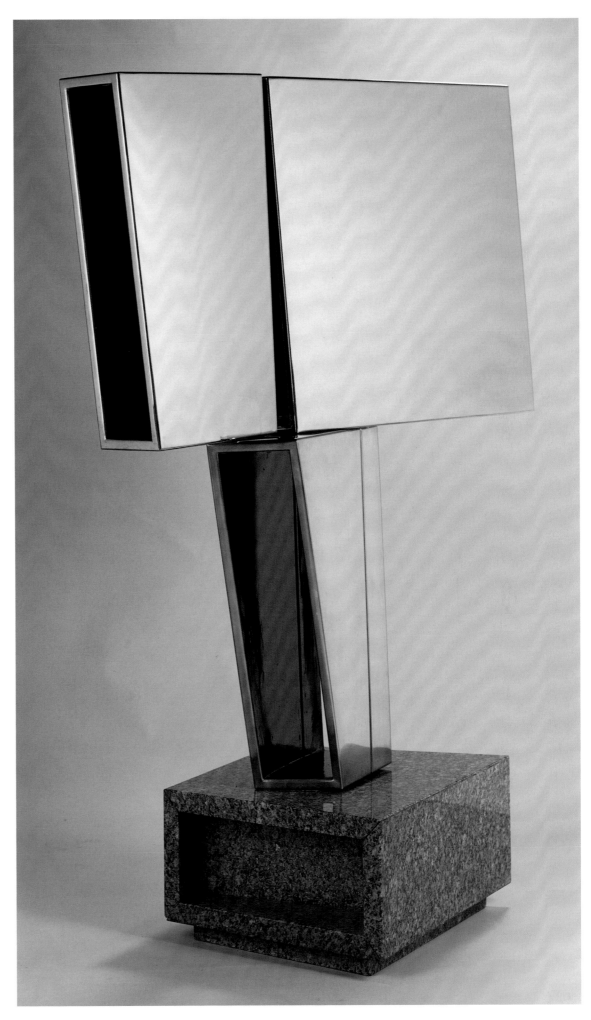

RICHARD DIEBENKORN

(Portland, Oregon, 1922–1993)
High Green, Version II from *Ocean Park*, 1992; Crown Point Press, San Francisco
Aquatint, 39⅞ x 23¾ (101.3 x 60.3)
Trial proof
Donated by Phyllis Diebenkorn, courtesy Lawrence Rubin • Greenberg Van Doren • Fine Art, New York

SOL LEWITT

(Hartford, Connecticut, 1928)
Complex Form 16, 1990
Painted aluminum, 72 x 36 x 36
(182.9 x 91.4 x 91.4)
Donated by the artist

LARRY BELL

(Chicago, 1939)
Untitled vapor drawing (#MELGLB2) blue, 1985
Glass coated with aluminum and silicon monoxide, 29½ x 23½
(74.9 x 59.7)
Donated by Eileen and Peter Norton

PROVENANCE
Jeffrey Linden Gallery, West Hollywood, California

AGNES MARTIN

(Maklin, Saskatchewan, Canada, 1912)
Untitled #4, 1998
Acrylic and graphite on canvas, 60 x 60 (152.4 x 152.4)
Donated by the American Art Foundation

ELLSWORTH KELLY

(Newburgh, New York, 1923)
Untitled, 1994; Gemini G.E.L., Los Angeles
Lithograph, 22 x 27 (55.9 x 68.6)
Special proof of ten
Donated by Riva Castleman

JOEL SHAPIRO

(New York, 1941)
Untitled, 2000
Pastel, 54 x 51⅝ (137.2 x 131.1)
Donated by the artist, courtesy PaceWildenstein Gallery, New York

JOSEPH DUMBACHER JOHN DUMBACHER

(Indianapolis, Indiana, 1960)
line 28 line 47 line 48, 2000
Stainless steel and stabilized dry pigment, three elements,
27 x 2⅝ x ¾ (68.6 x 6.7 x 1.9); 27 x 4⅜ x ¾ (68.6 x 11.1 x 1.9);
27 x 4⅜ x ¾ (68.6 x 11.1 x 1.9)
Donated by the artists, courtesy Patricia Faure Gallery, Santa Monica

PETER HALLEY

(New York 1953)
Pre-Hysteria, 1999
Acrylic, day-glo, metal acrylic, and
roll-a-tex on canvas, 103 x 60
(261.6 x 152.4)
Donated by Mireille and
James I. Levy, Lausanne

PROVENANCE
Grant Selwyn Fine Art, New York and
Los Angeles

BRYAN HUNT

(Terre Haute, Indiana, 1947)
Precog #1, 1996
Cast concrete and limestone: sculpture,
53 x 19 x 10 (134.6 x 48.3 x 25.4);
base, 37½ x 14 x 14 (95.3 x 35.6 x 35.6)
Donated by the artist

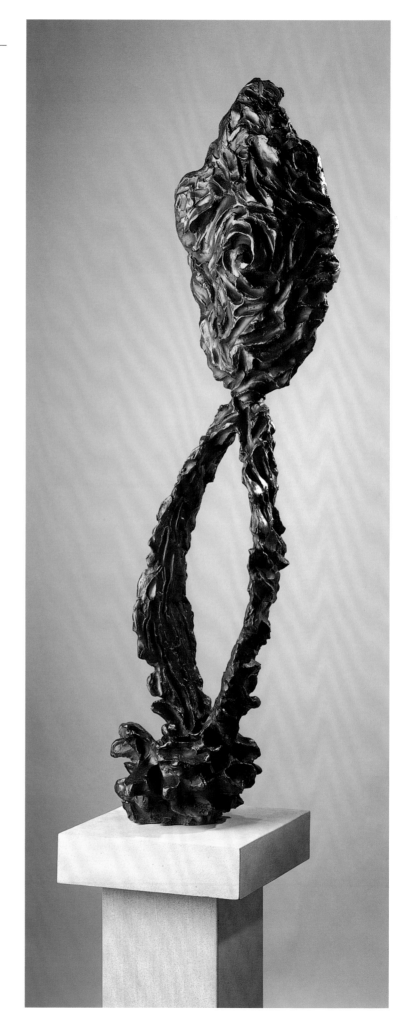

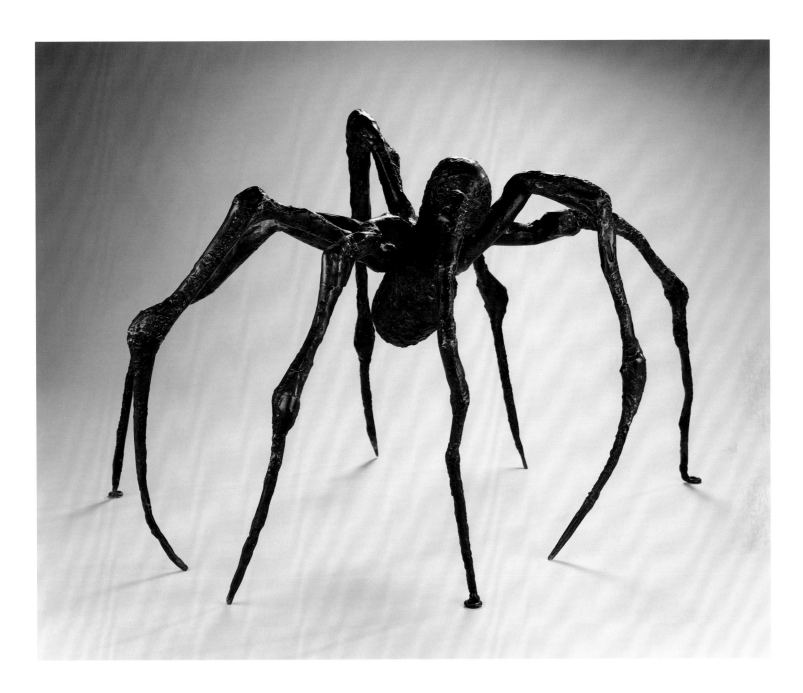

LOUISE BOURGEOIS

(Paris, 1911)
Spider, 1995
Bronze, 24¾ x 38 x 38 (62.9 x 96.5 x 96.5)
Donated by the artist, courtesy Cheim & Read, New York

JAMES SURLS

(Terrel, Texas, 1943)
Around the Devil, 1983
Oak, 28 x 35 x 24½ (71.1 x 88.9 x 62.2)
Donated by the Patsy R. and Raymond D. Nasher Collection,
Dallas, Texas

PROVENANCE
Collection of the artist

BEVERLY PEPPER

(Brooklyn, New York, 1924)
Bedford Column, Tillius Bronze, 1990
Bronze, 102 x 13 diameter (259.1 x 33)
Donated by Peter and Kirsten Bedford

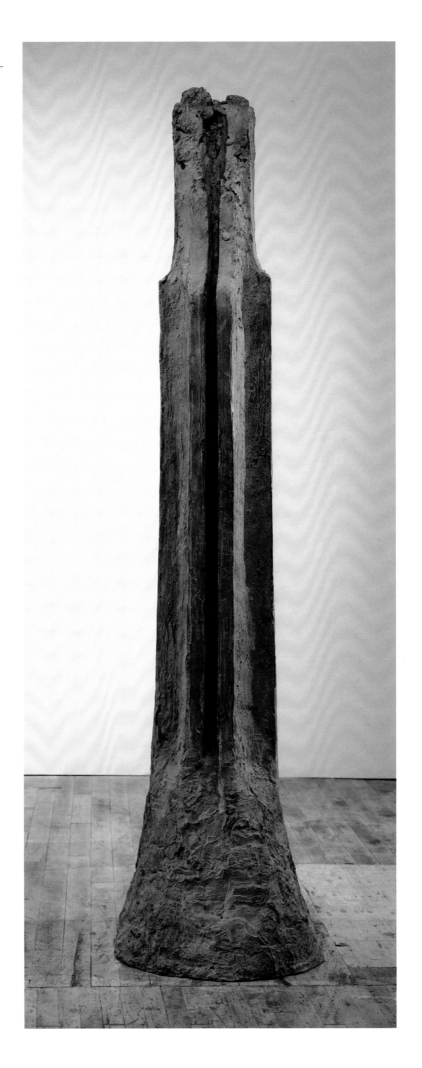

FRANK STELLA

(Malden, Massachusetts, 1936)
Shards V, 1982; Petersburg Press, New York
Offset lithograph and screenprint, 39¾ x 45¼ (101 x 114.9)
Edition of 100
Donated by the Patsy R. and Raymond D. Nasher Collection, Dallas,
Texas

Studio Debris (maquette for mural in The Princess of Wales
Theatre, Toronto), 1993
Mixed-media construction, 33 x 88½ x 24 (83.8 x 224.8 x 61)
Donated by David and Audrey Mirvish

STEVEN SORMAN

(Minneapolis, Minnesota, 1948)
as remembered from *inside weather*, 1998;
Tyler Graphics Ltd., Mount Kisco,
New York
Lithograph, screenprint, relief, collage,
bronzing, stencil, and hand-coloring
by the artist, 21 x 77 (53.3 x 195.6)
Edition of 30
Donated by Kenneth Tyler, Tyler
Graphics Ltd., Mount Kisco, New York

Years and When, 1984; Tyler Graphics
Ltd., Mount Kisco, New York
Woodcut, relief, etching, lithograph,
and collage, 58 x 38 (147.3 x 96.5)
Edition of 28
Donated by Kenneth Tyler, Tyler
Graphics Ltd., Mount Kisco, New York

CAIO FONSECA

(New York, 1959)
Tenth Street #26, 1993
Acrylic on canvas, 31 x 25½ (78.7 x 64.8)
Donated by Cynthia Hazen Polsky

SAM GILLIAM

(Tupelo, Mississippi, 1933)

Fragrance, 1989

Oil, wood, molded polyurethane, and lithograph, 41 x 50½ x 12

(104.1 x 128.3 x 30.5)

Donated by The Honorable Nancy Rubin and Mr. Miles Rubin

See to Green, 2000
Acrylic on birch, with piano hinges,
37¾ x 22 x 7¾ (95.9 x 55.9 x 19.7)
Donated by the artist

JESÚS BAUTISTA MOROLES

(Corpus Christi, Texas, 1950)
Disc Spiral, 2001
Dakota/Fredericksburg granite,
88 x 50 x 10½ (223.5 x 127 x 26.7)
Donated by the artist, courtesy
Barbara Davis Gallery, Houston

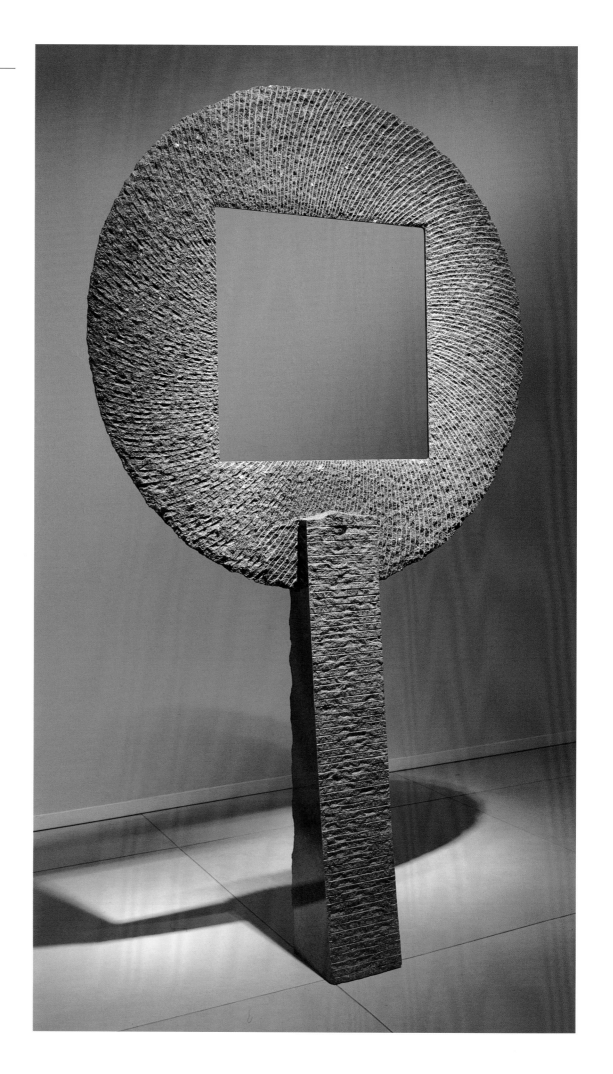

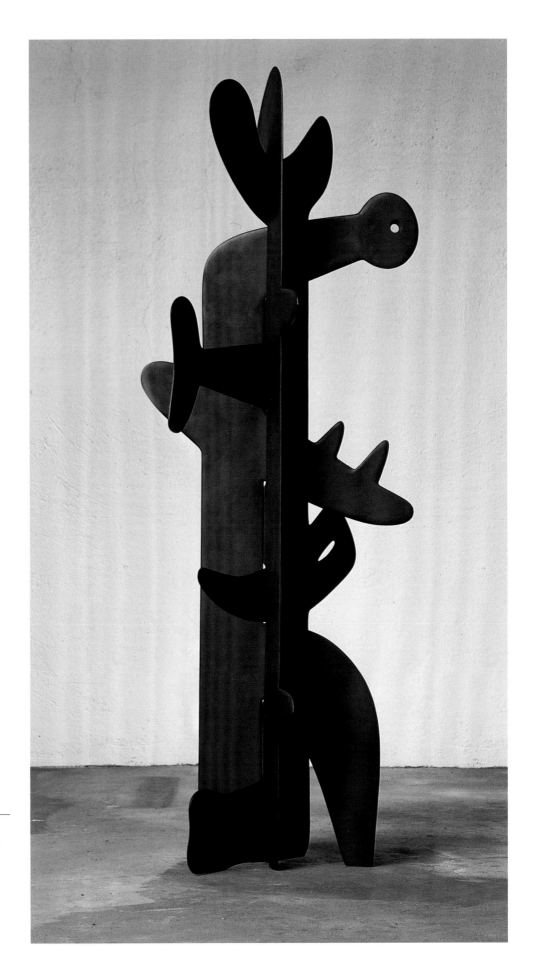

ISAMU NOGUCHI

(Los Angeles, 1904–1988)
Trinity (Triple), 1945; constructed 1988
Bronze, three elements, 55 x 22 x 20
(139.7 x 55.9 x 50.8)
Artist's proof
Donated by the Isamu Noguchi
Foundation, Inc.

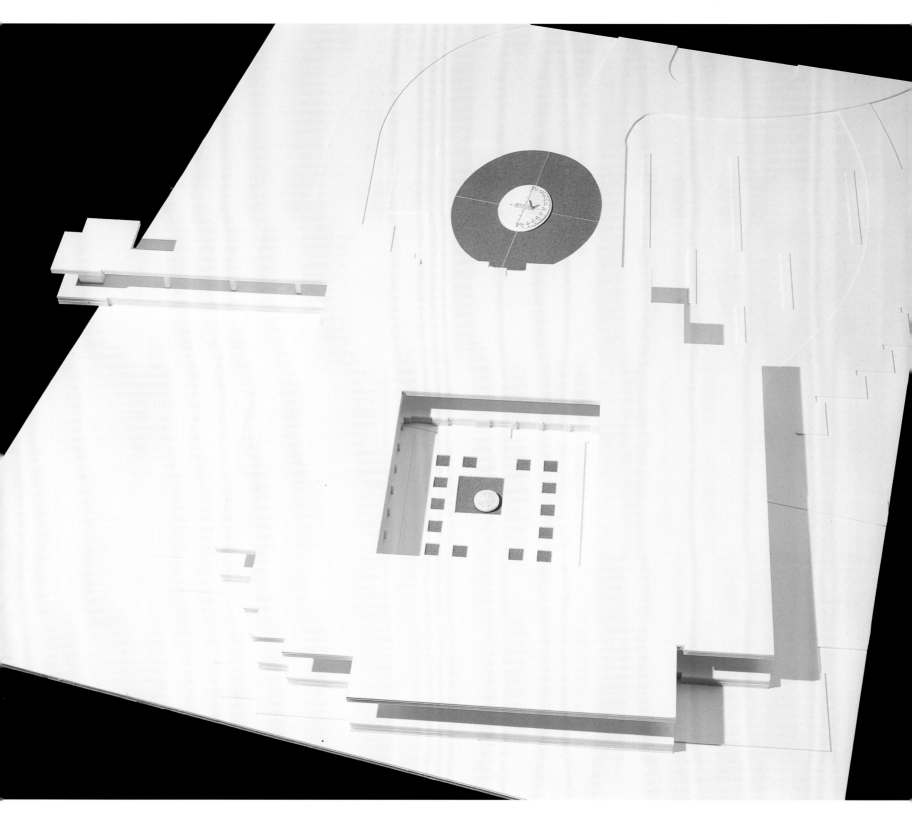

MAYA LIN

(Athens, Ohio, 1959)
Maquette for an installation commissioned for the United States
Consulate General, Istanbul, Turkey, 2001
Museum board, 3 x 50 x 42 (7.62 x 127 x 106.7)
Designed for a building by Zimmer Gunsul Frasca Partnership,
Portland, Oregon; planned for completion in 2003
Made possible by The Horace W. Goldsmith Foundation and donated
funds, and supported by Nancy McElroy Folger,
Elizabeth S. Kujawski, and Elizabeth K. Pozen

Equatorial sundial/water table (fixed dial plate
lies parallel to the Equator, pointing north)
c. 118 (299.7) diameter

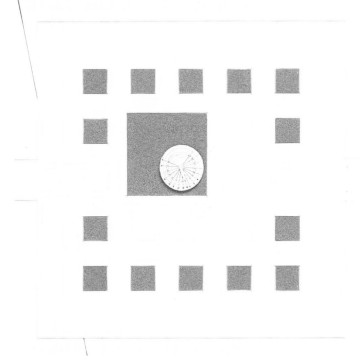

Analemmatic sundial (as a vertical element, a person
stands in a spot designated by the sun's position)
c. 324 (823) diameter

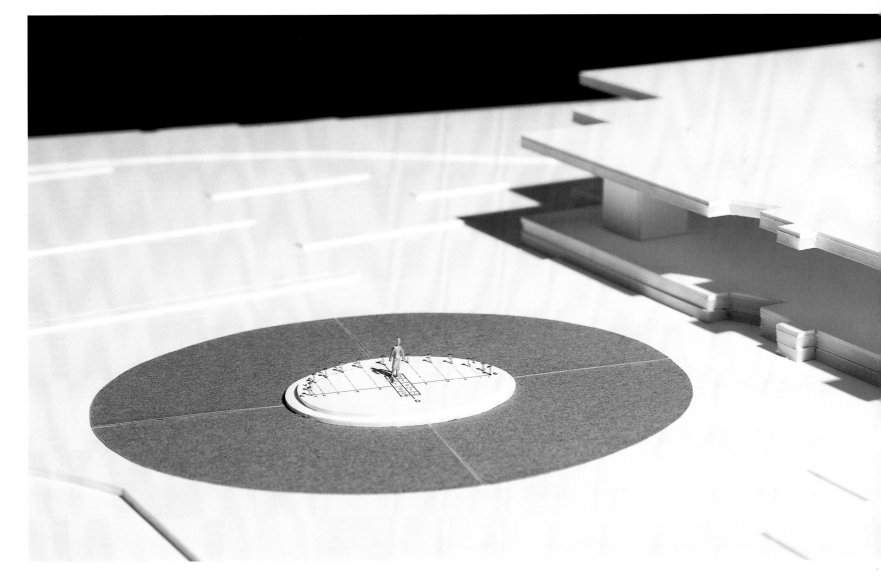

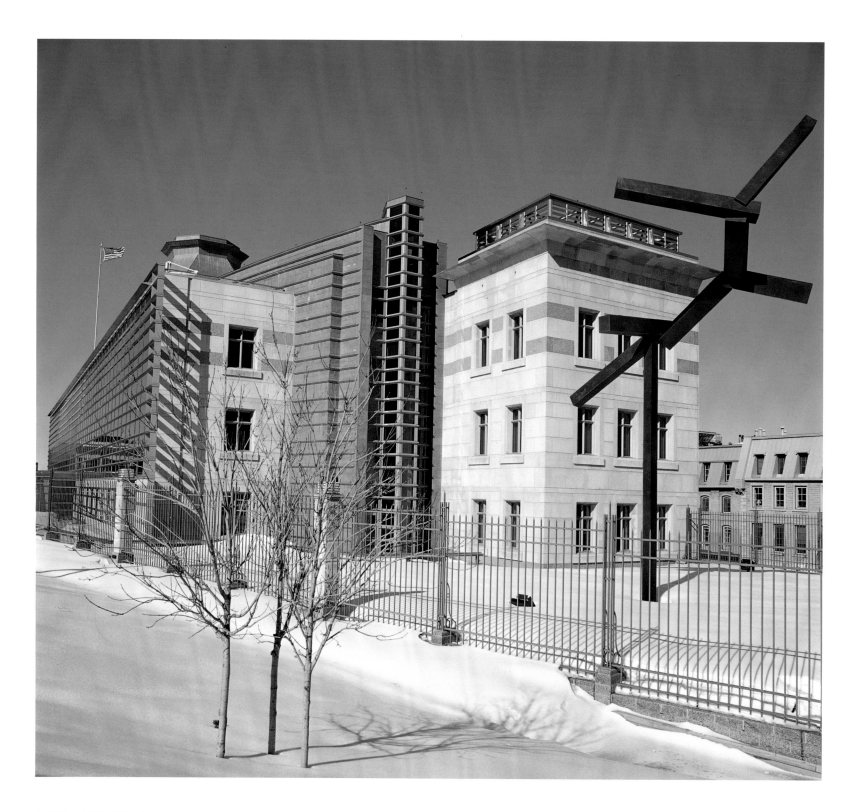

JOEL SHAPIRO

(New York, 1941)

Conjunction, 1999

Bronze, 480 x 324 x 192 (1219.2 x 823 x 487.7)

Donated by the artist and purchased with funds donated by Arne Glimcher;
Barrick Gold Corporation, Toronto; The Horace W. Goldsmith Foundation;
Power Corporation of Canada, Montreal; TrizecHahn Corporation, Toronto;
an anonymous donor; and members of the Millennium Committee
Commissioned for the grounds of the United States Embassy in Ottawa,
Ontario, Canada; building designed by David Childs, chief architect, and
Gary Haney, Skidmore, Owings & Merrill, New York, and completed in 1999

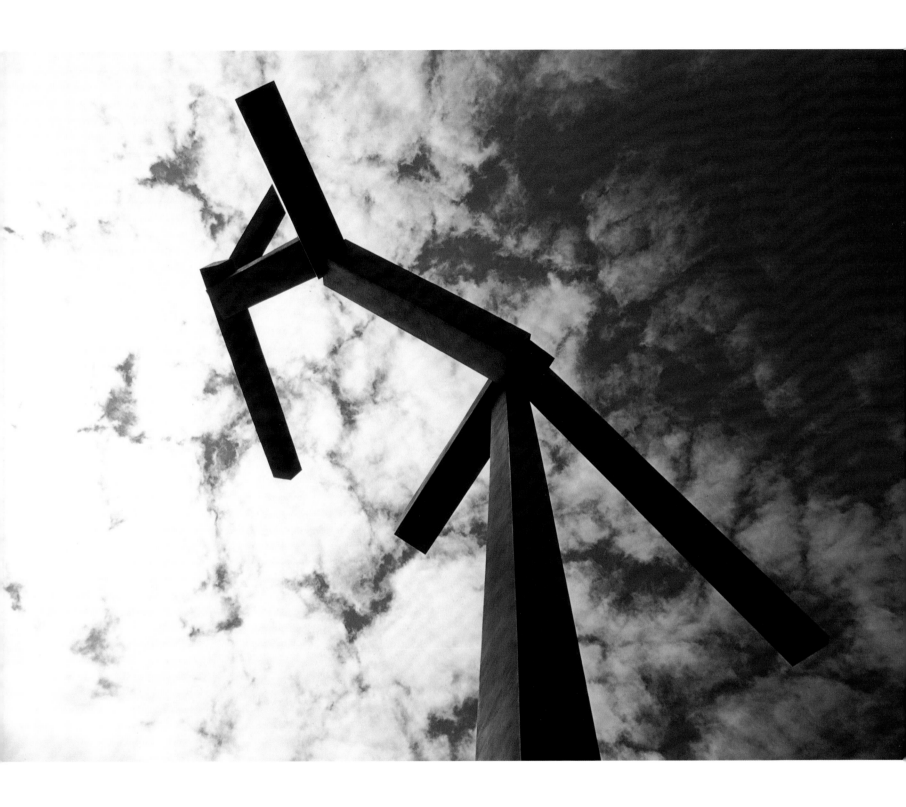

RONI HORN

(New York, 1955)
Untitled (A Brink of Infinity), 1996
Photolithograph, 42 x 58 (106.7 x 147.3)
Edition of 12
Donated by the artist and Matthew Marks Gallery, New York

Index of Artists